IMAGES
of America

MILLBRAE

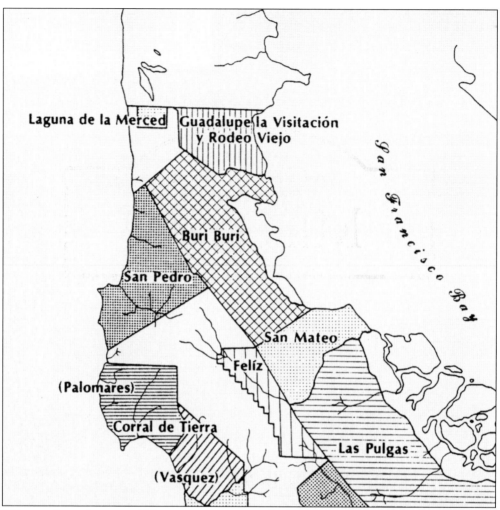

This map shows the original Mexican land grants on the San Francisco peninsula, comprising large areas of ranchos. Rancho Buri Buri, stretching from present-day South San Francisco all the way to the northern border of San Mateo, was the area from which today's Millbrae was created.

IMAGES
of America

MILLBRAE

Millbrae Historical Society

ARCADIA
PUBLISHING

Copyright © 2007 by Millbrae Historical Society
ISBN 978-0-7385-4790-9

Published by Arcadia Publishing
Charleston SC, Chicago IL, Portsmouth NH, San Francisco CA

Printed in the United States of America

Library of Congress Catalog Card Number: 2007924988

For all general information contact Arcadia Publishing at:
Telephone 843-853-2070
Fax 843-853-0044
E-mail sales@arcadiapublishing.com
For customer service and orders:
Toll-Free 1-888-313-2665

Visit us on the Internet at www.arcadiapublishing.com

To the past, present and future citizens of Millbrae, our place in the sun. We are especially thankful to the members of the Millbrae Historical Society, whose dedication has led to a lasting appreciation for our city's history. Of course, we have a lasting debt to those pictured here who are no longer with us. They are, from left to right, (first row) Matt Boxer, Virginia Mason, and Tony Medar; (second row) Silvio Massolo, Don Griffin, and Fran Baxter; (third row) Vivian Bowers, Brian Kestner, and Joe Hakl; (fourth row) Elizabeth Bele, Frank Palmieri, Bob Thurley, and Stewart Ruggles; (fifth row) John Brucato, Ted Dal Don, and Kay Tracy. Not pictured here are Victor Graff and Valli Slate.

CONTENTS

Acknowledgments 6

Introduction 7

1. Beginnings 11

2. The City 33

3. Transportation 57

4. Schools and Churches 69

5. A Baseball Town 81

6. Millbrae Means Business 85

7. Life in Millbrae 105

ACKNOWLEDGMENTS

The inspiration to publish this book came from the enthusiasm of the members of the Millbrae Historical Society and from community citizens who are proud of our little city and eager to learn more about its history and heritage.

The Millbrae Historical Society was formed in 1970. Because there was no museum building, the collected artifacts were displayed in the Millbrae Library, Wells Fargo Bank, and the First National Bank in Millbrae. The dream of the members to have a museum finally became a reality with the acquisition of the cottage that now houses the Millbrae Museum.

The following people are recognized and thanked for their help and special talents in writing captions, scanning images, and doing research: Alicia Espinoza, retired Millbrae city clerk, for her knowledge of the history of the city; Lois Way for her computer knowledge; Tom Dawdy for his professional photograph donations; Barry Goyette for the comprehensive album of Royal Container (one of the very early businesses in Millbrae); Ernest Gee for his family album about his grandfather, who was the last blacksmith operating in Millbrae until the 1940s; Richard English for his family history, his photographs, and for donating many artifacts; Gloria and Leonard Borusso for starting the assortment of chapters; Angela Zink and Joe Teresi for writing captions and scanning pictures; June Lyerla for her family history and her help in contacting people who were residents of Millbrae in days gone by; Helen Habeeb for her proofreading; and Darold Fredricks for his help in organizing the program for publication and for the use of his collection of photographs. We also acknowledge Mary Vella-Treseler for her expertise in primary editing; Jack Gardner for his research of early Millbrae businesses; John Poultney of Arcadia Publishing, without whose help this book would never have been published; and Millbrae Museum curator Alma Massolo. Unless otherwise noted, all photographs are from the collection of the Millbrae Historical Society.

Due to the depth of research necessary to produce this book, we may have unintentionally overlooked someone. If we have failed to recognize anyone, we sincerely apologize. We appreciate the help of all who have given of their time and expertise toward the creation of this book.

INTRODUCTION

What we know of Millbrae's earliest beginnings tells of a rich, vibrant history, perhaps even a romantic era. It stretches from the time of the Native Americans to periods of Spanish and then Mexican rule and finally to incorporation as a city in the state of California. The local Native American dwellers, known as the Ohlone tribe, lived in marshes along the San Francisco Bay and the surrounding hills. They subsisted on a diet of shellfish, deer, and rabbit, and they made their dome huts and canoes from reeds gathered in the marshes. Artifacts of their sojourn here have been discovered as late as the 1950s, and, remarkably, Native American shell mounds still exist on Mount San Bruno.

It was in November 1769 that Capt. Don Gaspar de Portola discovered San Francisco Bay from Sweeney Ridge and changed the destiny of its occupants. Among his many historic accomplishments, he founded the Presidio of San Francisco as a military garrison for the Spanish king. The missionaries who accompanied the soldiers on their discovery treks founded the California missions, including Mission Dolores in San Francisco. The king's soldiers and the missionaries tended their separate herds of cattle and maintained farmlands in San Francisco and along the peninsula to sustain them.

A young man named Jose Antonio Sanchez (born 1751), who had a wife and young son, joined the Spanish garrison. His son, Jose Antonio Sanchez Jr. (born 1774), also joined the garrison at age 17 and began his military service patrolling the area that began in San Francisco and reached 50 miles south to San Jose. Upon the retirement of Jose Antonio Sanchez Jr., the first Mexican governor of California, Louis Arguello, granted Rancho Buri Buri to him as a reward for his 45 years of loyal service to Spain and Mexico (following its independence in 1821). The land reached from South San Francisco at Mount San Bruno to Adeline Drive in Burlingame and from San Andreas to the bay. Sanchez was required to build a house on the land, and in 1836 he built an adobe house with outbuildings on a site near El Camino Real and Millbrae Avenue (where the Travelodge Motel stands today). He lived there in his hacienda for seven years until his death on June 22, 1843. He left his property to be divided among his 10 offspring.

The land that makes up Millbrae was primarily the inheritance of two of the Sanchez sons, Jose de la Cruz and Manuel. Manuel's land comprised much of today's Millbrae and downtown San Bruno. It was Manuel's son, Juan, who built the 16-Mile House to provide income for his elderly mother, Francisca Sotello. These lands were later divided and sold.

Jose de la Cruz Sanchez inherited 1,500 acres bounded by Millbrae Avenue, El Camino Real, Skyline Boulevard, and Adeline Avenue in Burlingame. The land-rich heir borrowed $5,000 against his inheritance, but he defaulted on the loan, and the land was sold at sheriff's auction to James Wilson for $1,000. Wilson resold the property to Darius Ogden Mills in 1860 for $20,000. Fortunately for his family, Jose de la Cruz purchased 300 acres from his brother Manuel in the Ludeman Lane area and built a home near the present site of the Millbrae Pancake House.

Darius Ogden Mills, the gold rush entrepreneur, built a grand estate on his new property, situated close to where Spring Valley School stands today. He acquired the right-of-way for a train

depot nearby in Millbrae, and he also owned the land where Mills Field (which later became San Francisco International Airport) was established. Mills also established the Millbrae Dairy along El Camino Real to supply milk and income for his estate. His business partner, A. F. Green, ran the dairy operations. The Greens' house still stands at No. 1 Lewis Avenue. Darius Ogden Mills died in residence in Millbrae on January 3, 1910. The mansion stood for many years, but it burned to the ground in 1954.

The dairy was the primary source of employment in Millbrae, followed by the West Coast Porcelain Works in the 1920s, which changed its name to the Royal Container Company in the 1930s. With increased employment came a post office, an electric railroad, general stores and saloons, and the telephone company. There were also farms of produce and flowers.

The idea for the city first came about in 1927, when residents wished to incorporate the newly plotted and subdivided 280 acres of land north of the Millbrae Villa. A 1931 vote for incorporation failed. Without a city government, the residents formed the Millbrae Civic Club, which took care of most of the necessary services of running a community, such as maintaining the train depot, providing garbage collection, raising funds for the volunteer fire department, seeing to school needs, and securing a telephone exchange. The club also repeatedly asked the San Mateo County Board of Supervisors to provide police protection.

In 1937, neighboring city Burlingame showed interest in annexing the Mills Estate area, but the area was claimed by Millbrae. This may have prompted the formation of the Millbrae Taxpayers Association in 1944. On January 12, 1944, a meeting was called at Taylor School by Earl R. Kuhn, president of the Millbrae Lions Club and superintendent of the Millbrae Elementary School District. The meeting brought together civic organizations, business representatives, and members of special districts to discuss the growth of the community and possible solutions to the civic problems that came with it. Feelings ran high toward incorporation. The Millbrae Taxpayers Association studied the costs of incorporation versus annexation to Burlingame and the addition of other special assessment districts. Their decision was to adopt a resolution favoring incorporation in February 1944, but a straw vote defeated the incorporation idea. San Francisco then made a failed bid for fusion with San Mateo County, further complicating the governmental issues.

In 1945, Burlingame attempted to annex the Mills Estate by embracing Millbrae, too. In August 1945, incorporation was endorsed for the second time by the Millbrae Taxpayers Association, prompted by several events: Burlingame's attempt at annexation, the county board of supervisors turning over Millbrae's sewer facilities to the Lomita-Capuchino Sanitary District, and Millbrae's ineffective protest against routing the Junipero Serra highway through the community. Douglas Morgan was elected president of the taxpayers association, and he subsequently named an incorporation committee. In April 1946, boundaries were proposed, with Skyline Boulevard forming the western boundary and the Mills Estate forming the southern boundary. The area stretched from what is now the industrial area of Burlingame (Millsdale) to the waterfront along Bayshore Road and north to the Lomita Park Elementary School, but it excluded Lomita Park.

In response, the Mills Estate residents asked Burlingame to annex a 100-foot strip of land around Mills Estate in order to block the entrance of utilities into this area from Millbrae, with the supposed intention of avoiding new assessments that would come with incorporation.

Millbrae property owners signed a petition for incorporation and submitted it to the county clerk on September 3, 1946. The board of supervisors approved the petition and set an election date for December 10, 1946. Burlingame promptly filed suit to nullify the incorporation resolution. California Superior Court judge A. S. Schotky upheld the petition, and the case carried all the way to the California Supreme Court, which upheld the decision on Millbrae's petition for incorporation by a vote of 5-2. No decision was made on the 100-foot strip.

The election took place on December 10, 1946, and Millbrae's first city council was elected. Of the 23 candidates who placed their names on the ballot, William Leutenegger was named mayor, and Harold Taylor, George Warman, James Kilpatrick, and George Kelly were named to the council. This did not deter Burlingame, however, which went to court on December 12 to halt the canvassing of votes. On December 13, Judge James Atteridge of Santa Cruz granted

Burlingame's request, stopping the functioning of Millbrae as a city and preventing the seating of the first council.

There followed two and a half years of lawsuits and countersuits regarding the validity of the 100-foot strip and the dismissal of Burlingame's suit halting the canvassing of votes. On January 12, 1948, Judge Atteridge dismissed Burlingame's suit, and the San Mateo County Supervisors canvassed the votes.

On January 14, 1948, the elected members of the Millbrae City Council drove to Sacramento, where Secretary of State Frank M. Jordan handed them a certificate making Millbrae a municipal corporation of the sixth class. That same day, Millbrae's first city council was sworn in by county clerk W. H. Augustus. At 8:00 p.m., the council held its first organizational meeting at Taylor School.

Burlingame filed another appeal against Judge Atteridge's decision to reopen the canvassing of votes. At the April municipal election, Jim Kilpatrick topped the voting, followed by Leutenegger, Taylor, Warman, and Oehm. Taylor was elected mayor. The city continued to operate under an adverse decision of Burlingame's appeal still pending.

In March 1949, the court of appeals reversed Judge Atteridge's decision on the legality of the "wall" around the Mills Estate, making Millbrae's incorporation illegal because some of Mills Estate was now legally within the city of Burlingame. City attorney John W. Coleberd was instructed to petition the state supreme court to review the case.

At this point, the Millbrae Incorporation Committee, in the best interests of the new city, sought a solution to move the city forward without any further delay by requesting that the 357 acres of Mills Estate property located east of the railroad tracks be deleted from Millbrae's proposed boundaries. Burlingame would annex the 357 acres. Senate Bill No. 315 was speeded through the legislature with assistance from Assemblyman Richard Dolwig and Sen. Harry Parkman. It was signed by Gov. Earl Warren on June 30, 1949, and Millbrae at long last became its own city.

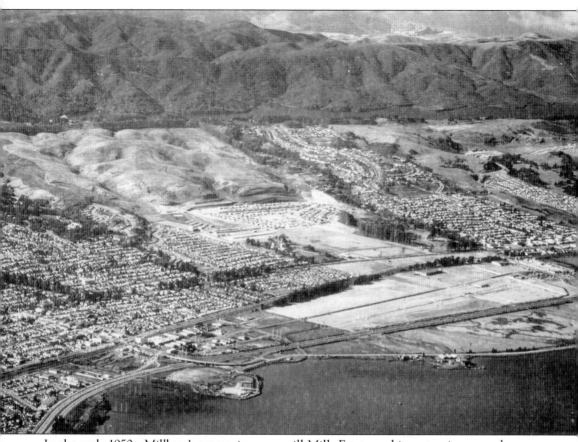

In the early 1950s, Millbrae's centerpiece was still Mills Estate and its extensive grounds, seen here at center. Along the bay, the old Bayshore Highway skirts the waterfront, now populated by hotels, restaurants, and office buildings.

One

BEGINNINGS

Millbrae's story is similar to that of many California towns: an early settler sets up an agrarian enterprise on a Spanish land grant, visionary settlers arrive and begin farming and building, and before long a city is born. Jose Antonio Sanchez arrived here following the "discovery" and sparse colonization of the San Francisco peninsula that had occurred after Gaspar de Portola's first viewing of the region from atop Sweeny Ridge in 1769. His son, Jose Antonio Sanchez Jr., gained the title to Rancho Buri Buri, the huge rancho stretching from what is now South San Francisco to San Mateo. Upon his death in 1843, his sons Jose de la Cruz and Manuel became the primary inheritors of what is today's Millbrae.

Later in the 1800s, Chilean native Custodio Silva purchased 168 acres of what is now the area between Taylor Boulevard and Anita Avenue, stretching roughly from today's El Camino Real to Skyline Boulevard. His family contributed much to the development of the area, providing properties for use by ranching operations and various farming concerns.

Other important players in Millbrae's development included the Spring Valley Water Company (which built a flume through here to transport water between San Mateo County and the booming metropolis of San Francisco, where it was in short supply) and the town's namesake, entrepreneur Darius Ogden Mills, whose business acumen during California's early years made him a fabulously wealthy man. For many years, his estate was one of the crown jewels of the peninsula. Like many others, Mills saw opportunity in the California Gold Rush, and he rose to the occasion, founding banks in Sacramento and the gold town of Columbia. Mills amassed a huge real estate empire south of San Francisco, and he had a hand in numerous business ventures, including the founding of a dairy and of the Bank of California. It is a wonder that Mills is not commonly mentioned with other early Californians who have become household names, such as the Crockers, Huntingtons, and Stanfords, as he was every bit their equal in many respects.

The members of Jose Antonio Sanchez's family were, in essence, the founders of Millbrae. Jose Antonio Sanchez traveled north with the Juan Baptista de Anza expedition from Sinoloa, Mexico, in 1776, accompanied by his wife and infant son, Jose Antonio Jr. At 17 years of age, Jose Antonio Jr. joined the Mexican Army, and he rose quickly in the ranks. During his 44 years of service, he patrolled the area from San Francisco to San Jose, clearing the area of Native Americans. On September 23, 1835, in recognition of his retirement, the Mexican governor of Alta California awarded him the 14,600-acre Rancho Buri Buri, which encompassed the land from the north end of South San Francisco to Burlingame and from the San Francisco Bay to the hills overlooking the Pacific Ocean. Upon his death, his 10 children each inherited one-tenth of the 14,600 acres. Jose de la Cruz Sanchez and his brother Manuel Sanchez inherited what is now Millbrae.

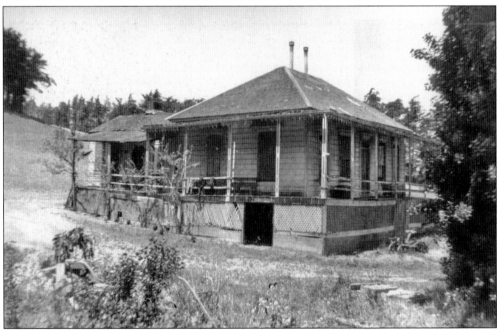

This is the home built by Jose de la Cruz Sanchez for his family. Located on Ludeman Lane near today's Green Hills Country Club and the Millbrae Pancake House, the house was occupied by the family for two generations. When this photograph was taken in the 1920s, the house had been abandoned.

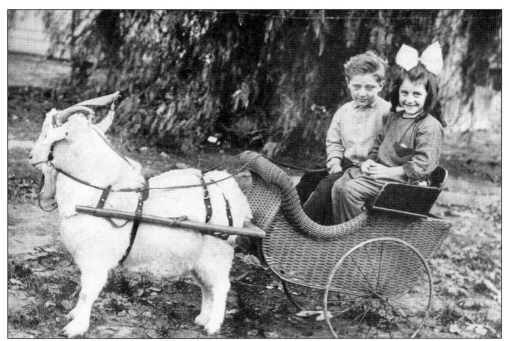

Gerald and Mildred Cavanaugh, two young members of the Sanchez family, enjoy a ride on a goat-powered conveyance around 1895.

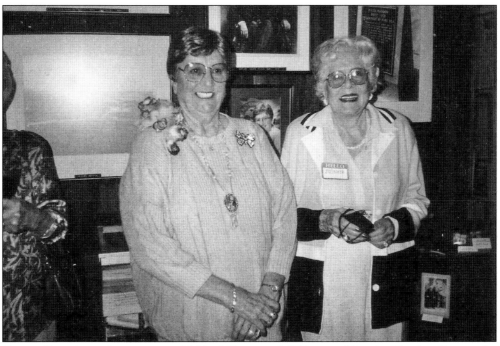

Pictured here in modern times are Mildred Cavanaugh Wilson and Juanita Flanders Owens, the great-great-great-granddaughters of Jose Antonio Sanchez Sr.

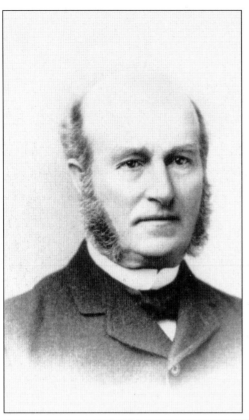

Darius Ogden Mills has been recognized as a powerful man in the financial world. Mills, a native of Salem in Westchester County, New York, was born on September 5, 1825. At age 22, became a cashier of the Merchants Bank of Erie County with a one-third interest in the business. He was attracted to the discovery of gold in California, and in 1848 decided to leave for California via Panama. Finding no available passages, he proceeded to Peru, where he bought a schooner for $10,000. He sold passages to 100 men who were also joining the Gold Rush in California. When Mills arrived in San Francisco, he opened banks in Columbia, Sacramento, and San Francisco and became the most successful financier in California. He made his fortune from banks, railroad companies, silver mines in the state of Nevada, and other entities. He founded the Bank of California in San Francisco, which is still in operation today. Jane Templeton Cunningham became his bride on September 5, 1854, and they became the parents of a son and a daughter.

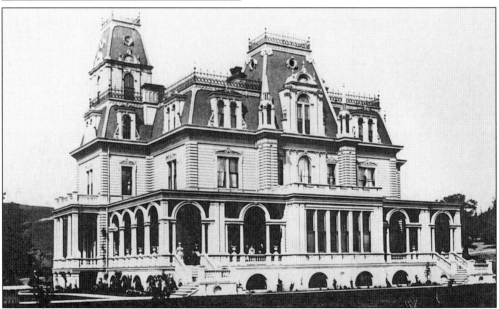

The Mills Mansion was an imposing three-story structure featuring 42 rooms, a conservatory, a carriage house, a gatekeeper's house, and various manicured gardens. Among the visitors of this storied estate was Pres. Ulysses S. Grant, who was entertained with a quiet and exclusive dinner on September 30, 1879. The mansion was destroyed by fire in 1954.

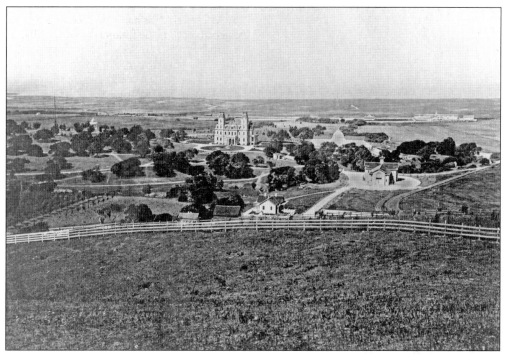

This c. 1895 photograph of the Mills Estate, taken from the hills above town, shows the mansion and its various outbuildings with the swampy shoreline of San Francisco Bay in the background.

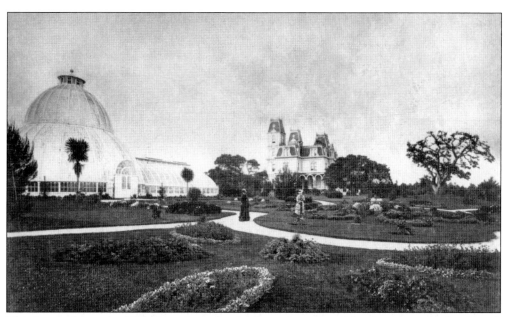

This image shows the Mills Estate's garden in the early stages of development and the domed, glassed-in conservatory, which was similar to the conservatory of flowers in San Francisco's Golden Gate Park.

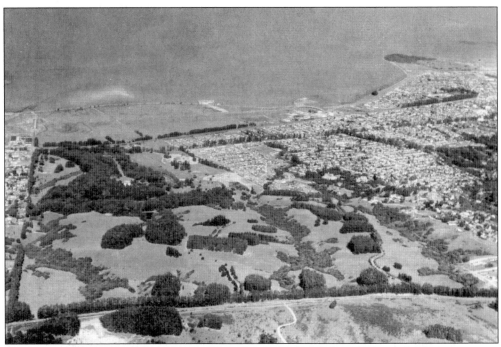

The Mills Mansion was surrounded by extensive pastures, which helped facilitate the dairy operations in later years. The Millbrae Historical Society has placed a bronze marker at the former site of the mansion, which is at the flagpole of the Spring Valley School at 817 Murchison Drive.

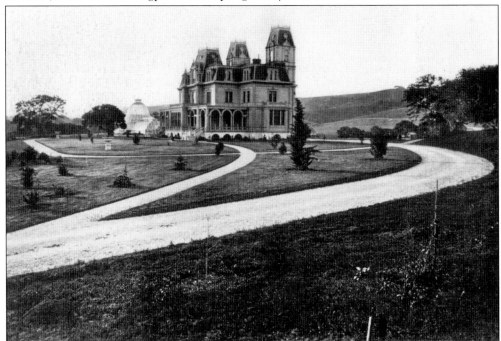

The mansion had a huge 20-by-30-foot dining room, a 10-foot-tall grandfather clock, servant's quarters on the third floor, a large cooking area in the basement, and even a bowling alley. The dirt road shown approaching the main building in this *c.* 1890 view is today's Murchison Drive.

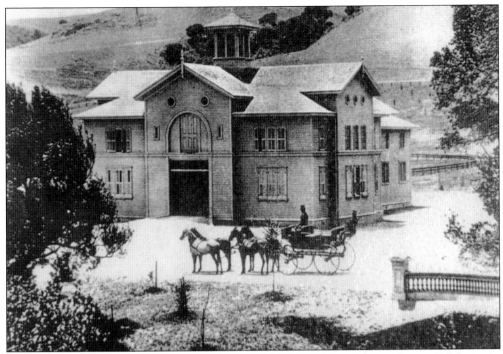

The carriage house of the Mills Estate, seen here in the 1890s, was set to the rear of the main house and was larger than most contemporary homes. Like the main house, it had ornate 14-foot ceilings in its rooms.

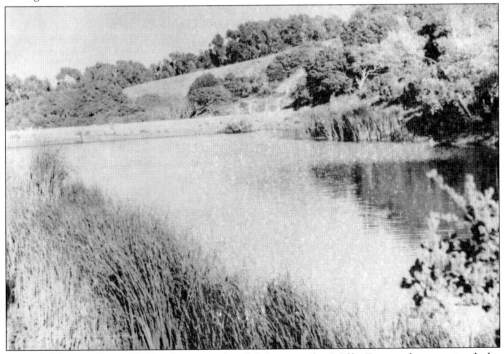

Pictured here is one of the three artificial lakes on the Mills Estate that serviced the Millbrae Dairy.

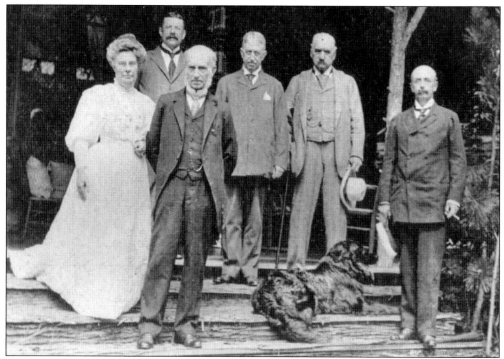

This striking group of D. O. Mills's family members posed for a photograph around 1890. Pictured are, from left to right, Mrs. Whitelaw Reid, Whitelaw Reid, Darius Ogden Mills, two unidentified people, and Ogden Mills.

During World War II, the heirs of Darius Ogden Mills turned the mansion over to the United Seamen's Services to be used as a convalescent home for the battle-weary men. The practice continued until 1947.

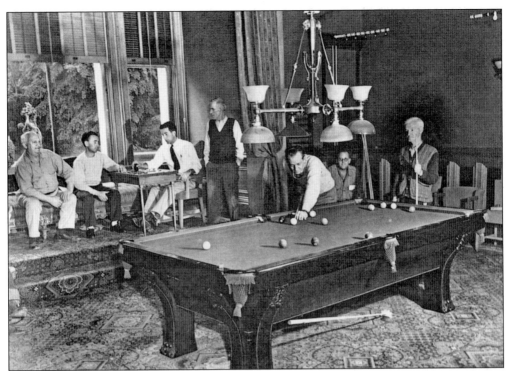

In this mid-1940s image, merchant seamen play a game of pool. The mansion was a grand place for them, with beautiful gardens to walk in. Organizations in the area came in to entertain them. Many veterans were rehabilitated and were able to live normal lives again.

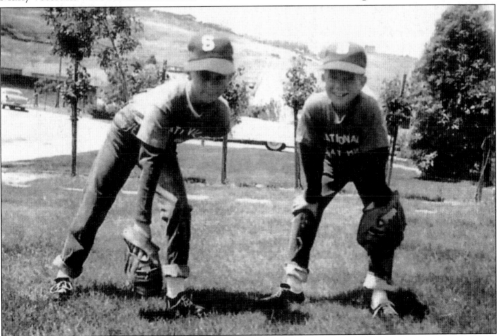

Two young boys, Robert (left) and Richard Young, play baseball on the grounds of the Mills Estate in the 1940s.

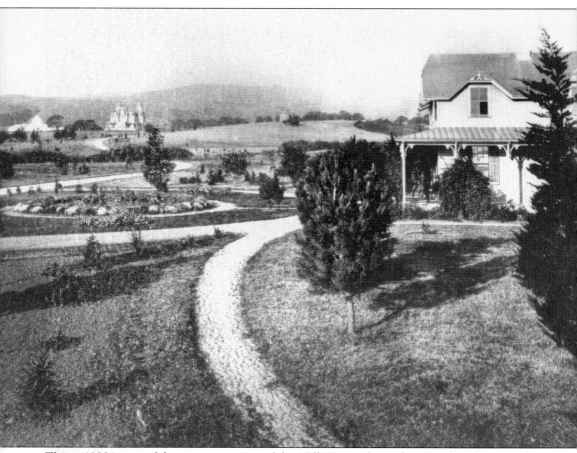

This *c.* 1900 image of the western portion of the Mills Estate shows the caretaker's home in the foreground. The estate had many curved walkways and roads. The estate land was sold by the Mills heirs to the Paul W. Trousdale Construction Company of California and Clint W. Murchison of Dallas. In December 1954, the first row of houses was built and sold for around $14,000 each. The developers planned to build 200 more homes, and many lots were sold to private contractors.

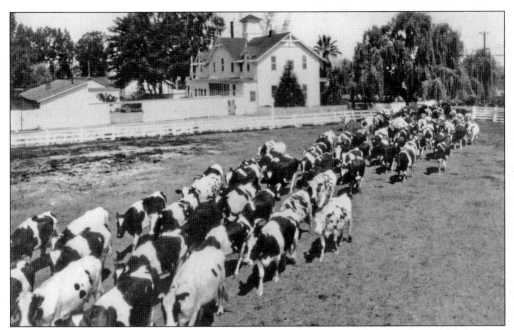

Millbrae Dairy took special pride in its quality cows (registered Holsteins) and immaculate facility. It was one of the county's largest dairies. Grazing land encompassed several thousand acres. In 1931, it was reported that 25 blue-ribbon cows from Millbrae Dairy were shipped on the Matson liner *Manukai* to a dairy in the Hawaiian Islands that wanted to improve its quality of milk.

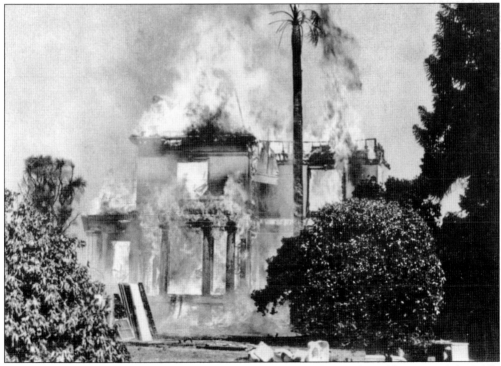

The most spectacular fire ever to happen in Millbrae was the accidental burning of the Mills Mansion in 1954. It was a tragic end to an elegant and unique building.

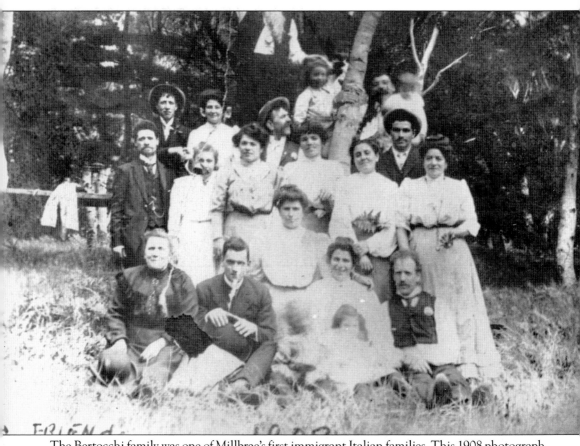

The Bertocchi family was one of Millbrae's first immigrant Italian families. This 1908 photograph shows the Bertocchi family and friends enjoying a day at the park at the site of present-day Ludeman Lane. Family patriarch Fortunato is wearing the hat at the left of the top row.

Fortunato Bertocchi came from Lucca, Italy, and settled in Millbrae in 1911. He and his wife, Mary, who he wed in 1909, had five children. Their son Eddie Bertocchi was the first Millbrae Chamber of Commerce man of the year in 1960. Eddie Bertocchi was very active in the Lions Club beginning in 1963 and coached the Lions' baseball team for 27 years. He was also a very dedicated member of the Millbrae Historical Society. Shown here is Fortunato Bertocchi's wedding picture.

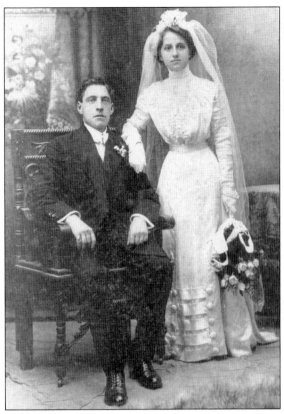

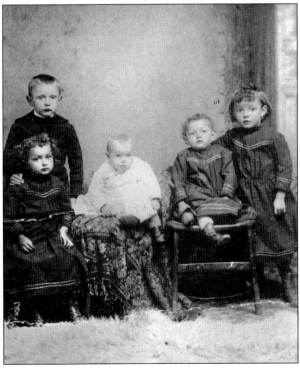

The members of the Furrer family were early residents of Millbrae. George and Mary Furrer came from Aldorf, Switzerland, in 1864. George Furrer worked a farm at the foot of the western Millbrae hills. This is a 1885 image of the Furrer children. They are, from left to right, Lou (standing), Julia, Pauline, Robert, and Erna.

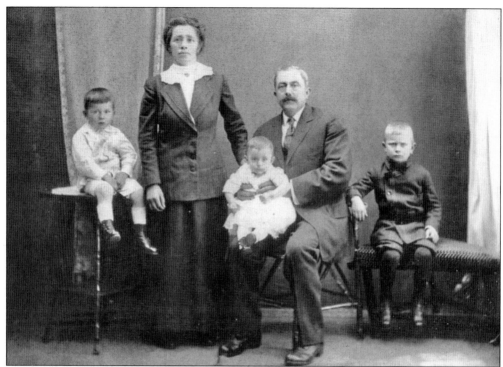

Antonio Massolo came to Millbrae in 1902 from Genoa, Italy, and started farming. In 1912, he married Maria, and she gave birth to three sons: Peter (1913–1933), Emilio (1917–1984), and Silvio (1919–2004). Emilio served as mayor of Millbrae from 1952 to 1953 and again from 1957 to 1958. Silvio pursued a career in business and investments. The eldest son, Peter, died accidentally at a very young age.

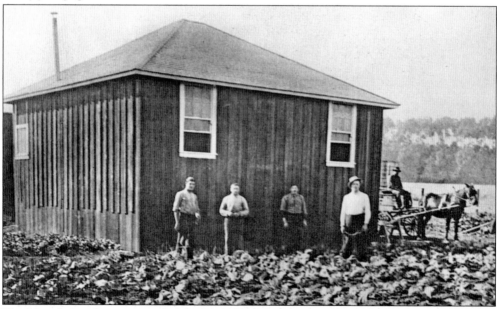

The Massolo farmhouse is seen here around 1920. This site is on Magnolia Avenue, which is now downtown Millbrae. Antonio Massolo is on the wagon behind a group of farmworkers.

Amadeo Berni and his wife, Julia, came to Millbrae from Italy in 1915. Pictured here around 1918 are Julia and son Joe.

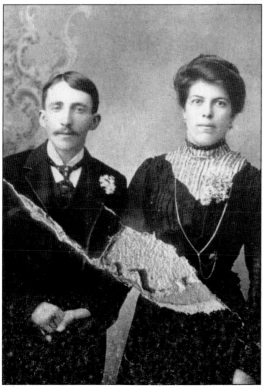

Amadeo Berni began farming in the Lomita Park area soon after his arrival. A son named Joe was born in 1912. In 1917, Amadeo died at a very young age. His wife, Julia, carried on the farm with help. When Joe was old enough, he helped his mother run the farm. Joe and his wife, Josephine, still reside in Millbrae.

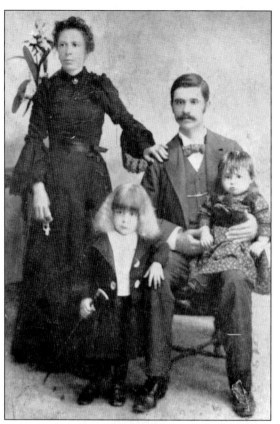

To escape conscription into the Italian Army in the late 1800s, Frank Fagnani Sr., together with his young bride, Christina, fled to Argentina on a coal boat. His sons Joseph and Frank Jr. were born in Argentina in 1903 and 1910, respectively. The family came to Millbrae in the early 1920s. Joseph Fagnani became an electrician and a builder, and his brother joined him in the Burlingame Electric business.

In this *c.* 1919 image, Caesar Dal Don tools about on an early farm truck that was used to deliver his flowers to the market. Specializing in baby roses, he was known as the "King of Roses."

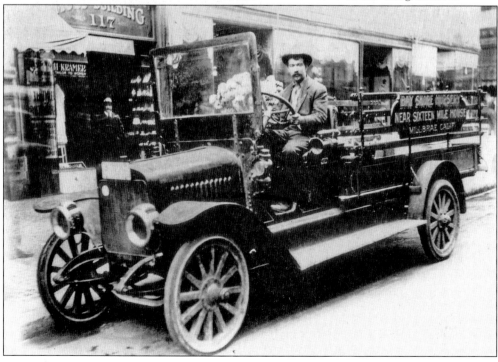

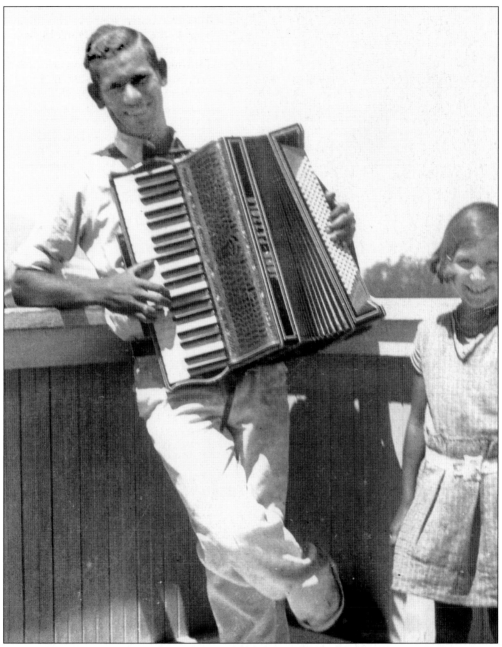

Caesar Dal Don's son Ted was a very talented accordion player. Every Italian family had at least one person who played the accordion.

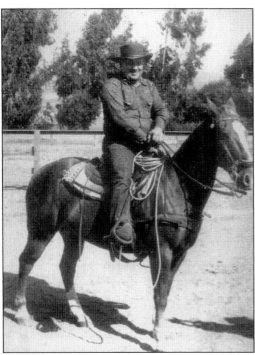

Robert Silva was the grandson of early Millbrae rancher Custodio Silva. Along with his brother, he ran a riding stable at the Millbrae Dairy barns.

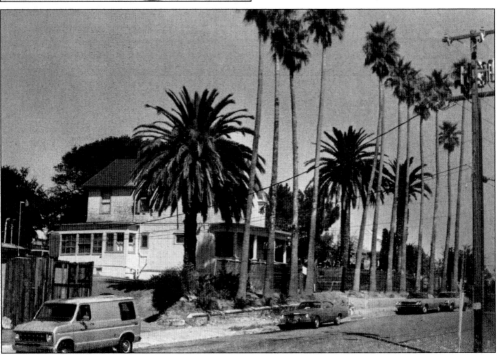

Seen here in modern times is the Silva home. Custodio Silva's family arrived in the 1870s from Chile and purchased a large horse ranch near Tanforan and many other properties in San Bruno and the Millbrae area. Son Manuel Silva moved to Millbrae in 1925 after Custodio's death, and he ran a horse stable in the old Millbrae Dairy. Manuel's sons Robert and Gordon ran the ranch with their father and continued doing so after he was killed in an accident.

The Bertocchi clan worked very hard in the fields. The children would work before going to school and again after school until it got dark. When the crops were to be harvested, the school would close; it would reopen when the crops had been harvested. The family played hard, as well, planning parties at the barn on the farm. Friends and neighboring families were all invited. Everyone brought something to share—food, wine, music, and more. Every New Year's Eve, the Bertocchis planned a very special party.

Molly Cozzolino Figone was born in San Francisco in 1922. She married George Figone in 1942, and together they leased different parcels of land in San Bruno and Millbrae. Each parcel of land was eventually sold for residential development. The last parcel they leased, located next to St. Dunstan's Church, was used to grow chrysanthemums. With land becoming so scarce, they decided to cease their flower-growing business. The Figones were the last of the flower growers in Millbrae.

Female members of the family of early Millbrae resident Alfred Gee pose outside the family home at 585 Chadbourne Avenue in 1936.

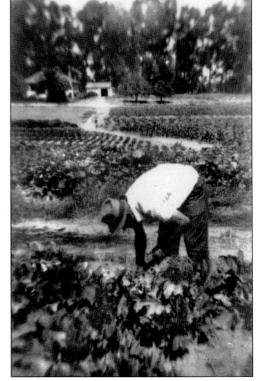

Most farm jobs were backbreakers. When they were picking violets, farmworkers' knees would suffer. In this c. 1910 image, a worker is shown in a flower field near present-day Meadow Glen Avenue.

John Brucato was born in Sicily on May 12, 1905. He began his career with the San Francisco Water Company by collecting rents from tenants in the Silva tract and the Ludeman Lane area. He founded the farmers' market in San Francisco, and in 1970 he became the first president of the newly formed Millbrae Historical Society. He was instrumental in procuring the cottage that is now the Millbrae Museum.

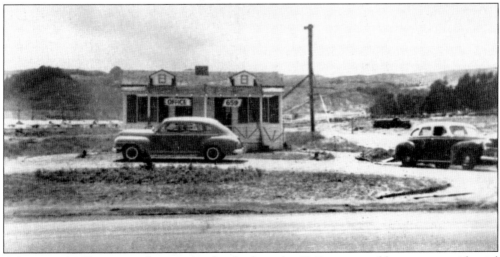

A house in Millbrae cost plenty today, but back in the 1940s, one could procure a residential lot for around $500 and a house for just a few thousand more. Seen here in 1946, the office of the Meadow Glen Development, a residential housing development, sits near the site of today's Safeway store. The developer of this tract was Max Schmidt.

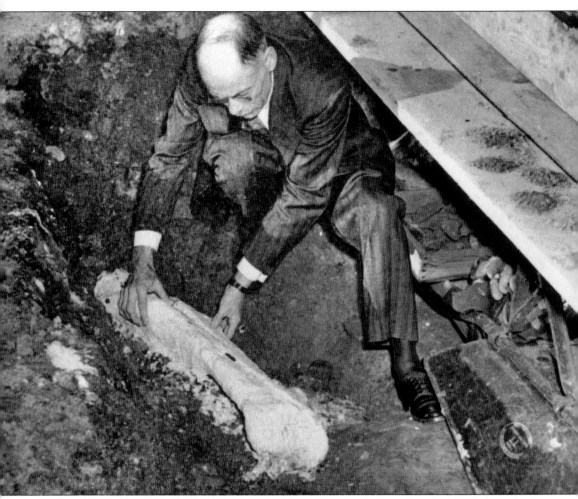

Dinosaurs in Millbrae? In December 1943, the answer was a resounding "yes." Workers digging foundations for homes in the Bayside Manor subdivision (located east of the BART station and west of Highway 101) unearthed fossil remains estimated to be 100,000 to 500,000 years old. Elephant tusks measuring eight feet in length, the shoulder blade of a mammoth creature, molars, jawbones, and ribs told us that these prehistoric creatures actually roamed this area. Dr. Frank Stanger, president of the San Mateo County Historical Association at that time, is shown here retrieving a skeletal remain of a very large prehistoric creature.

Two

THE CITY

The city of Millbrae is nestled on the San Francisco peninsula, 15 miles south of San Francisco proper, with a land area of about 15 square miles and about 21,000 residents. Most live on the slopes of the hilly terrain to the west, while to the east lies San Francisco Bay, with lagoons, wetland marshes, walking and biking trails, and an array of waterfront hotels and restaurants. Millbrae and its northern neighbor San Bruno share the honor of bordering the San Francisco International Airport.

Because of its unique location on the bay, Millbrae is an important transportation hub. The Bay Area Rapid Transit (BART) system has its southern terminus here, with links to east bay cities, San Francisco, the airport, and SAMTrans buses that connect throughout the county. The main north-south highways of the peninsula, 101 and 280, do not cut through Millbrae but instead flank its eastern and western boundaries. In the hills above town are the Crystal Springs and San Andreas reservoirs, part of the San Francisco city water supply, with clean water piped in from Hetch Hetchy near Yosemite.

Millbrae has a temperate climate, which enabled early settlers to establish flower and produce farms; many of the city's current residents are the third and fourth generations of those settlers. A dairy operated here for many years, originating at the site of the well-known Mills Estate, built by financier Darius Ogden Mills. The green hills here reminded him of his native Scotland, and thus he joined his name with brae, the Scottish word for rolling hills.

Transportation-wise, the airport, railways, and roadways gave rise to Millbrae's hospitality industry, and the city changed from flower fields to country homes for San Francisco's gentry, and then later to the residential enclave known today. Millbrae is not small, but its residents still cherish its small-town atmosphere, and along with civic leaders' efforts to keep life good here, all agree on the slogan: "Millbrae, Your Place in the Sun."

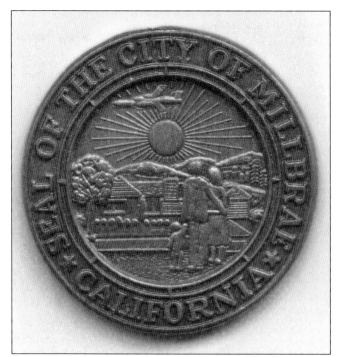

The official emblem of the city of Millbrae shows the basics for which this city is known: hills, houses, sunshine, and airplanes flying overhead.

The first city council of Millbrae, elected during the tumultuous incorporation time of 1946, consisted of, from left to right, (first row) James Kilpatrick, Mayor William Leutenegger, and Harold Taylor; (second row) George Warman, George Kelly, and R. P. Reifschneider. In 1948, the fledgling city received certification from Secretary of State Frank M. Jordan, making Millbrae a municipal corporation of the sixth class in the state of California.

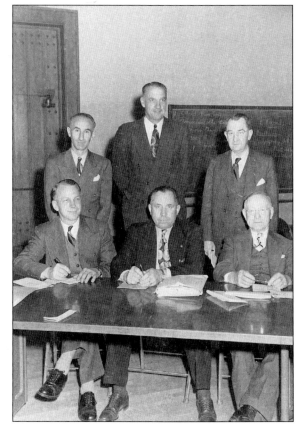

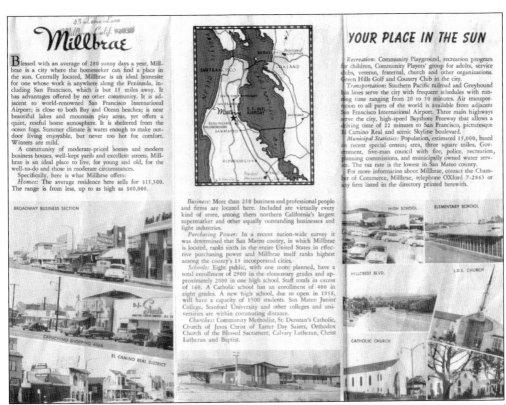

Millbrae

Blessed with an average of 280 sunny days a year, Millbrae is a city where the homeseeker can find a place in the sun. Centrally located, Millbrae is an ideal homesite for one whose work is anywhere along the Peninsula, including San Francisco, which is but 15 miles away. It has advantages offered by no other community. It is adjacent to world-renowned San Francisco International Airport; is close to both Bay and Ocean beaches; is near beautiful lakes and mountain play areas, yet offers a quiet, restful home atmosphere. It is sheltered from the ocean fogs. Summer climate is warm enough to make outdoor living enjoyable, but never too hot for comfort. Winters are mild.

A community of moderate-priced homes and modern business houses, well-kept yards and excellent streets, Millbrae is an ideal place to live, for young and old, for the well-to-do and those in moderate circumstances.

Specifically, here is what Millbrae offers:

Homes: The average residence here sells for $15,500. The range is from less, up to as high as $60,000.

Business: More than 250 business and professional people and firms are located here. Included are virtually every kind of store, among them northern California's largest supermarket and other equally outstanding businesses and light industries.

Purchasing Power: In a recent nation-wide survey it was determined that San Mateo county, in which Millbrae is located, ranks sixth in the entire United States in effective purchasing power and Millbrae itself ranks highest among the county's 15 incorporated cities.

Schools: Eight public, with one more planned, have a total enrollment of 2900 in the elementary grades and approximately 2000 in one high school. Staff totals in excess of 160. A Catholic school has an enrollment of 400 in eight grades. A new high school, due to open in 1958, will have a capacity of 1500 students. San Mateo Junior College, Stanford University and other colleges and universities are within commuting distance.

Churches: Community Methodist, St. Durstan's Catholic, Church of Jesus Christ of Latter Day Saints, Orthodox Church of the Blessed Sacrament, Calvary Lutheran, Christ Lutheran and Baptist.

YOUR PLACE IN THE SUN

Recreation: Community Playground, recreation program for children, Community Players' group for adults, service clubs, veteran, fraternal, church and other organizations. Green Hills Golf and Country Club in the city.

Transportation: Southern Pacific railroad and Greyhound bus lines serve the city with frequent schedules with running time ranging from 20 to 50 minutes. Air transportation to all parts of the world is available from adjacent San Francisco International Airport. Three main highways serve the city, high-speed Bayshore Freeway that allows a driving time of 22 minutes to San Francisco, picturesque El Camino Real and scenic Skyline boulevard.

Municipal Statistics: Population, estimated 15,000, based on recent special census; area, three square miles. Government, five-man council with fire, police, recreation, planning commissions, and municipally owned water service. The tax rate is the lowest in San Mateo county.

For more information about Millbrae, contact the Chamber of Commerce, Millbrae, telephone OXford 7-2863 or any firm listed in the directory printed herewith.

This brochure from the 1950s entices potential residents to come to Millbrae with the promise of 280 sunny days per year. Then, as now, the city traded on its location as a convenient suburban residential enclave with numerous transportation options (rail, freeway, and airport) and close proximity to San Francisco.

This image of El Camino Real and Hillcrest Boulevard in the early 1940s shows homes in the background on Hemlock Avenue and a Richfield gas station on the northeast corner. The sign at the left reads "Millbrae Drive-In Restaurant to be built at this site."

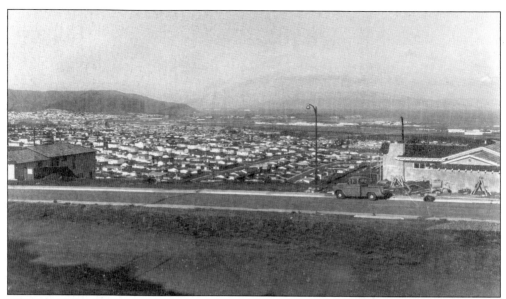

Telescope Hill, shown here during housing construction in the 1950s, is a scenic spot north of the Millbrae Highlands. Australian airline QANTAS (Queensland and Northern Territory Air Service) bought several homes here to house its workers.

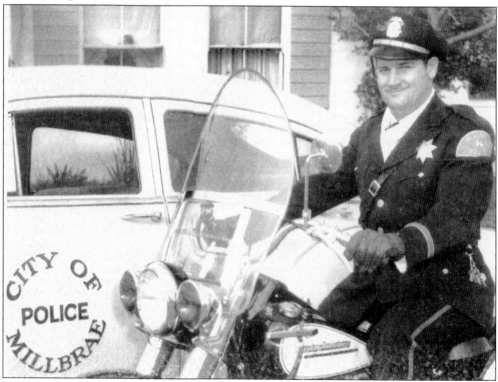

In 1948, when the city became incorporated, the Millbrae Police Department originated in a garage in an alley between Hillcrest Boulevard and La Cruz Avenue. The first men hired were Lawrence Picket, Bill Urbanski, and H. E. Schroeder. Urbanski, pictured here with the first car and motorcycle purchased by the city, was the first motorcycle officer.

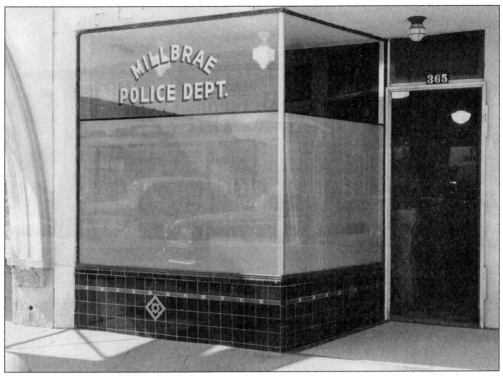

A few years after the city's incorporation, the police department moved to the storefront at 365 El Camino Real, next to the first city hall near La Cruz Avenue.

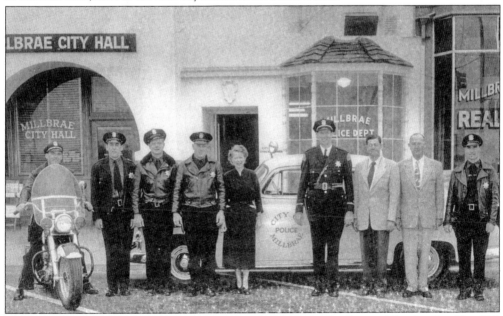

The Millbrae Police Department in 1955 included, from left to right, George Albright, Otto Bortfeld, Bob Lent, Alan Roper, police secretary Geri Goyette, Chief Larry Pickett, Commissioner Court Scranton, Commissioner Ken Robertson, and Frank Paglia. Ofc. Bill Urbanski is not pictured as he was serving in the Korean War at the time.

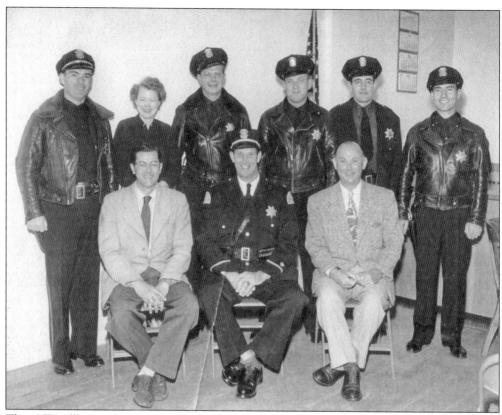

The 1957 Millbrae Police Department included, from left to right, (first row) Commissioner Court Scranton, Chief Larry Pickett, and Commissioner Ken Robertson; (second row) George Albright, Geri Goyette (secretary), Bob Lent, Allan Roper, Otto Bortfeld, and Frank Paglia.

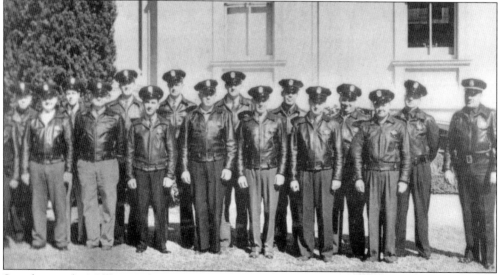

Seen here is the Millbrae Police Department's auxiliary force in 1941. This was a volunteer force much like the volunteer fire departments of today. The auxiliary was under the direction of police chief Frank Palmieri.

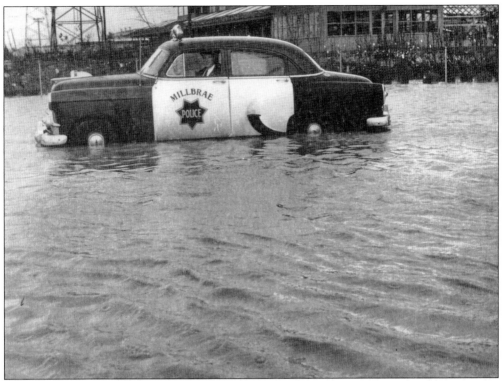

Chief Larry Pickett runs into a little trouble during a flood in 1955 near El Camino Real and Millbrae Avenue.

In 1957, the city built a new city hall at 621 Magnolia Street. The building also houses the police department and is still operating at this location.

April 25, 1998, was a black day for Millbrae. On that day, police officer David Chetcuti, 43, an 11-year veteran of the force, responded to a call of "shots fired—officer needs assistance." While trying to assist a fellow officer, he was gunned down and killed on Highway 101. Chetcuti was the only police officer in Millbrae's history to lose his life while on duty. He was well liked and respected by all who knew him, and his presence is truly missed in the community of Millbrae.

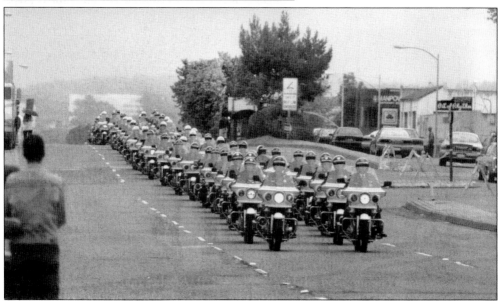

Thousands of solemn police officers in dress uniform stood 10 rows deep in the falling rain outside St. Dunstan's Church, white-gloved hands at their sides and black mourning stripes across their badges for David Chetcuti's memorial service. An estimated 350 motorcycles led the procession to Holy Cross Cemetery in Colma. Motorcycle cops came from nearby and from as far away as New York and Los Angeles. Vallejo police corporal Barry Bergsma observed that there is a brotherhood among all police officers, but it is particularly strong among motorcycle officers.

This advertisement was created by Neils Schultz, owner and developer of the beautiful Millbrae Highlands, in 1927.

This 1953 image looks southwest across upper Millbrae and the airport, with Coyote Point and San Mateo in the distance.

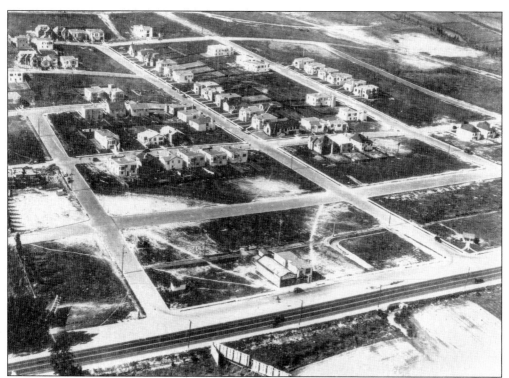

Millbrae development is seen in an aerial view from the mid-1920s. Towards the bottom of the photograph, El Camino Real can be seen. The area in the lower left corner of the image was known as the waterfront because the road (now Millbrae Avenue) led directly to the bay. In the early days, the water would occasionally wash up all the way across El Camino Real.

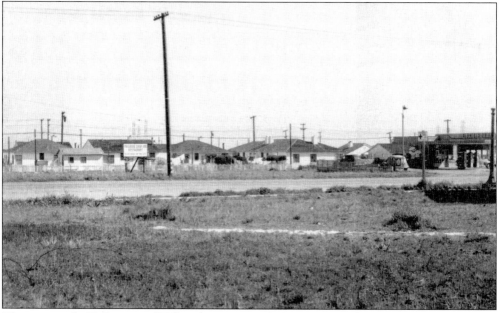

This is an early 1940s view of Hillcrest Avenue and El Camino Real near the site of the drive-in restaurant.

The Millbrae Highlands development, seen here in 1953, always sported excellent views of the upper peninsula.

Old Skyline Boulevard, at the very top of Millbrae, provided a western boundary to the city. This road was the main north-south route before Highway 280 was built, and is still in use today.

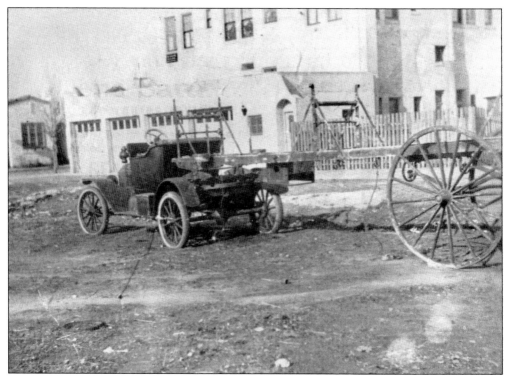

The first Millbrae fire truck, unveiled in the late 1920s, was called "Junior" by the firemen. Neils Schultz, the Millbrae Highlands developer, donated 450 feet of hose. When the firemen jumped on "Junior," their weight and that of the hose would cause the truck to scrape the ground—an untenable situation.

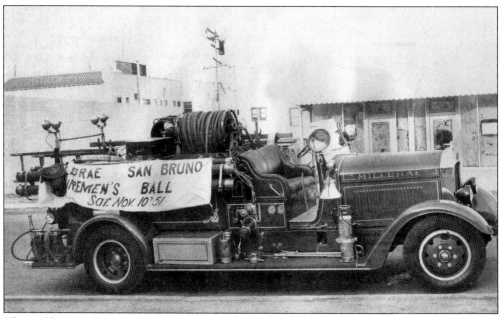

The Millbrae and San Bruno fire departments combined to hold a Firemen's Ball fund-raiser in 1951. Such events were always very well attended.

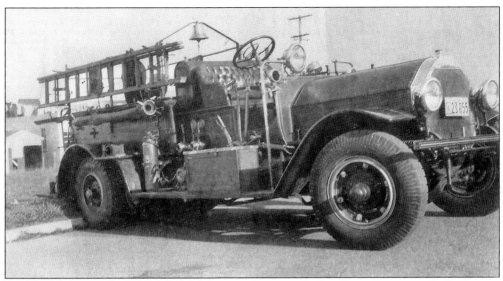

This 1936 La France fire truck was the first truck acquired after "Junior" was retired. Today this fire truck is also retired, but it is being refurbished by Millbrae firemen for its historical value.

The original firehouse consisted of one room, which was used as an entertainment room, a kitchen, and a bedroom for the two firefighters on duty each shift. Locals were drawn to the firehouse to watch television. Unfortunately, most of the visitors smoked, and before the firefighters retired for the night, the room had to be cleared of smoke. The station was later used as the Millbrae Players' theatre (see page 108).

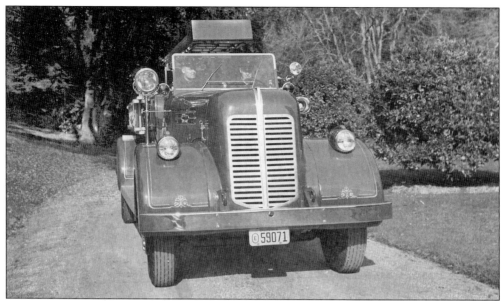

Pictured around 1930 is another of Millbrae's early fire trucks. Note the ornate finial on the front wheel covers.

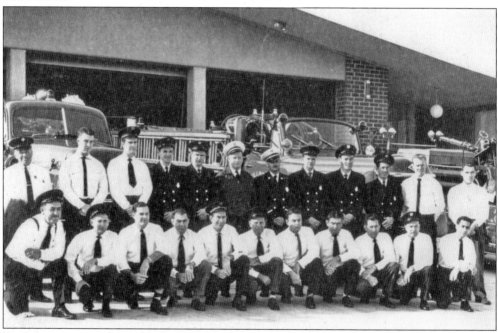

Firefighters pose in the mid-1950s in front of the new firehouse. Pictured are, from left to right, the following: (first row) Lou Gianni, Lee Silva, Harry Fiske, Don Ambrosia, Mel Massolo, Harry Erickson, Earnest Ferrari, Bruno Mattituck, Sil Massolo, Bill Mitchell, and Roy Copper; (second row) Fred Ratter, Don Herschel, Ray Beacon, Norman Brown, James Crawford, fire chief Les Pallas, Capt. Bob Kohler, Jerry Stern, Jeff Shackelford, Jim Friday, Harold Clark, and Less Cotter. Life was simpler in the early fire department days. A simple entry in the log book told of the city's most famous fire—the night the Mills Mansion burned to the ground and hundreds of people witnessed the end of an era.

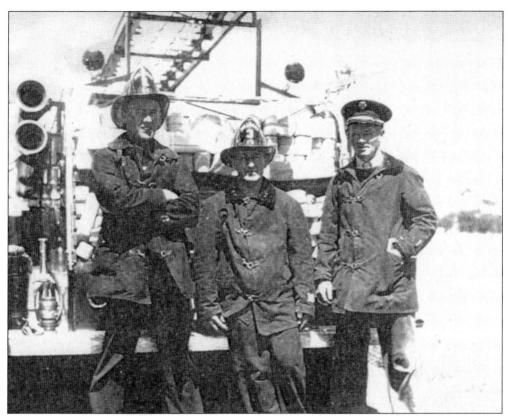

From left to right firefighters Allan Roper and Al Stoll and fire chief Les Pallas are pictured here with a Millbrae fire truck around 1958.

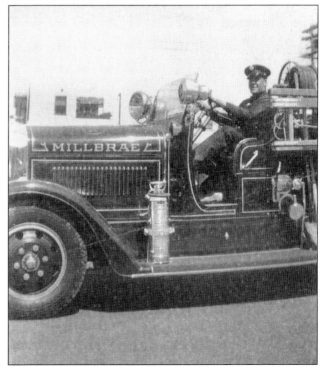

Martin Stillwell, a volunteer fireman, poses at the helm of the La France fire truck around 1950.

Marvin Church (left) and his son, Mark Church, were instrumental in creating the Millbrae Library, for which groundbreaking commenced in 1961. Marvin was a council member from 1958 to 1966; currently (2007) Mark is a supervisor for the County of San Mateo.

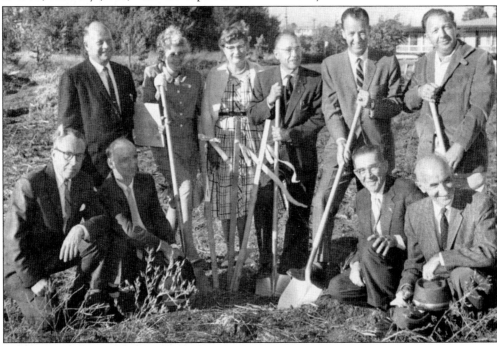

Present at the 1961 groundbreaking for the Millbrae Library were, from left to right, the following: (first row) Leo J. Sharps, Homer Chandler, C. "Doc" Carson, and George Warman; (second row) Webb Witmer, Josephine Waugh, Catherine Goodart, Douglas Morgan, Marvin Church, and Andrew Waechter. Since then, a new library has been built on the site of the old one. It was dedicated on November 20, 2004.

This 1930s aerial photograph shows significant residential development in the area west of El Camino Real (the long vertical line left of center), but not much to the east yet.

The Silva Tract, shown here in the 1930s from a vantage point near present-day Skyline Boulevard, is an area of million-dollar homes today. The land was originally owned by the Silva family. It was then purchased by the Spring Valley Water Company, which used it to run pipes to the main water pumping station (now the San Francisco Water Department on El Camino Real). On the left side of the image there appears to be an excavation; this is probably the Macco Pit, a large-scale dig used to provide earth for the expansion of San Francisco International Airport.

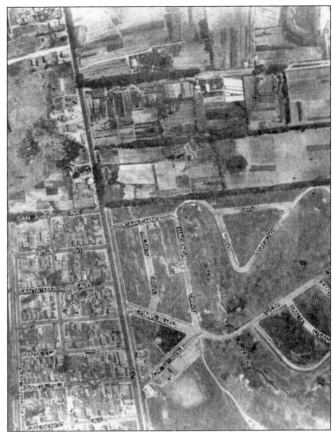

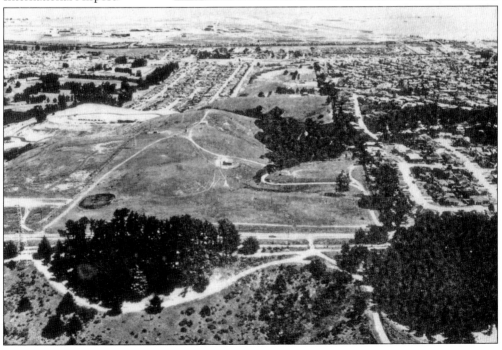

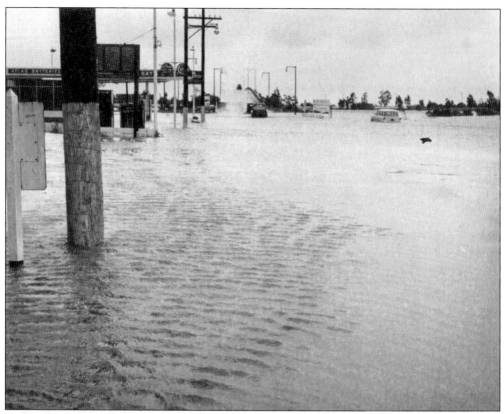

Until recent times, flooding was a real concern in Millbrae, as evidenced by this 1955 image of high water near the Millbrae Avenue overpass.

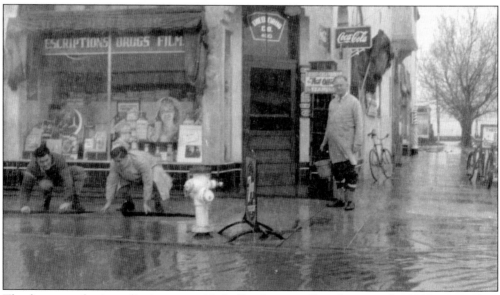

The downtown business district was at risk for flooding as well, as shown in this 1940 image taken near Broadway Avenue and Hillcrest Boulevard.

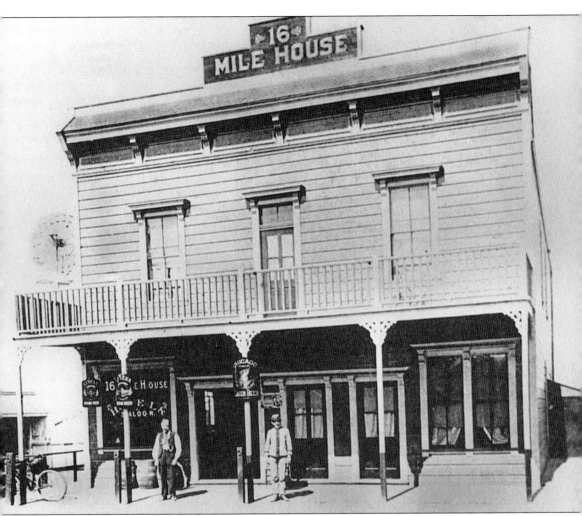

The 16-Mile House was a way station of sorts on the way south from San Francisco. It was one of several stops to serve travelers on the long route between San Francisco and San Jose along El Camino Real. The house was originally built in 1872 by Juan Sanchez, son of Jose Antonio Sanchez, to support himself and his widowed mother. It lasted almost 100 years.

In the 1940s, when this advertisement ran, the 16-Mile House was a popular spot for dinners and drinks. There were also many other dining establishments in central Millbrae at the time.

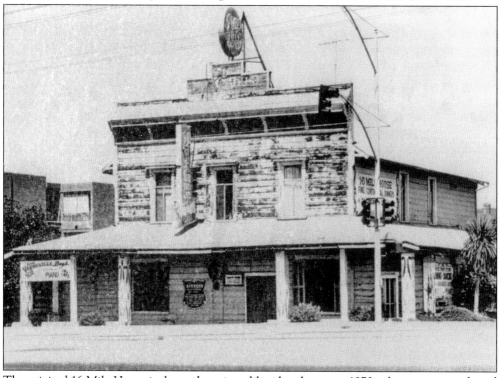

The original 16-Mile House is shown here in a dilapidated state in 1970, when it was purchased by a San Francisco concern. It was slated to be razed, and a group of preservationists tried unsuccessfully to delay the demolition, which finally occurred in 1971.

CITY OF MILLBRAE

STRAW BALLOT

ON

16-MILE HOUSE

TUESDAY, APRIL 14, 1970

MARK CROSSES (+) ON BALLOT
WITH RUBBER STAMP

THE CITY OF MILLBRAE has agreed to allow the 16-Mile House to be placed on the Northeast Corner of the Silva Ranch Park site (off of Palm Avenue) under the condition that the 16-Mile House will be moved, repaired, refurbished, maintained and staffed without any expenditure of Millbrae City Governmental funds. THE MILLBRAE HISTORICAL SOCIETY WILL PROVIDE ALL NECESSARY FUNDS IN ORDER TO GIVE YOU, THE MILLBRAE CITIZEN, A CULTURAL CENTER.

1. Do you agree with this philosophy of acceptance of this gift with no city financial support?	YES	NO
2. Taxpayers should support the cost of moving?	YES	NO
3. Taxpayers should support the cost of moving and maintenance?	YES	NO

In April 1970, the city held a straw poll to ascertain the feasibility of saving the 16-Mile House from the wrecker's ball. For a while, it appeared that the building might be saved, but financing fell through, and it was demolished in January of the following year. The 16-Mile House has since been rebuilt, and it operates today as a restaurant in a modern building along Broadway Avenue.

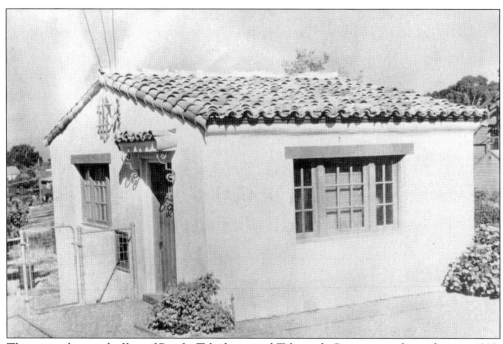

The original central office of Pacific Telephone and Telegraph Company is shown here in 1932. It has since been modified and converted into a residence, which is still occupied today.

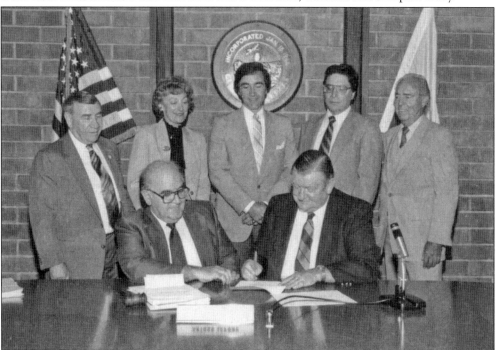

In the early 1980s, the lease was signed to locate the Millbrae Museum on city property. Pictured are, from left to right, council member Matt Boyer, Mayor Mary Griffin, council members Paul Van Inderstine and Frank Cannizzaro, Millbrae Historical Society historian Bill Baxter, council member Art Lapore, and Millbrae Historical Society president Bud Mason.

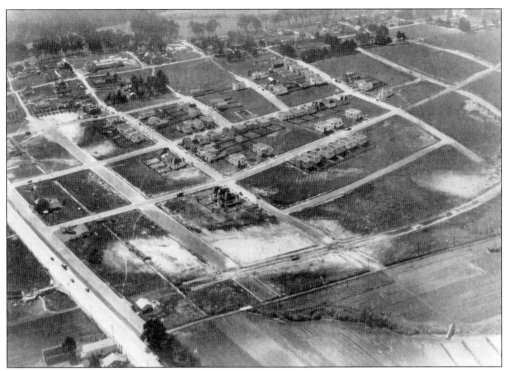

In the 1920s, Millbrae still had huge swaths of undeveloped land around its residential areas, as seen in this aerial view. Towards the bottom of the image is one of the many agricultural tracts that were in use for much of the 20th century. Despite significant development to the south in the San Mateo and Redwood City areas, much of Millbrae remained sparsely developed until the 1930s and 1940s.

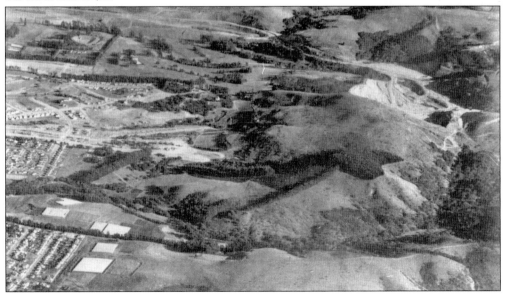

At the right of this 1946 image is the Macco Pit, a gigantic excavation of an entire hillside. The pit provided fill for the expansion of San Francisco airport, which was extending its footprint out into San Francisco Bay. The Macco Pit essentially leveled much of this hill.

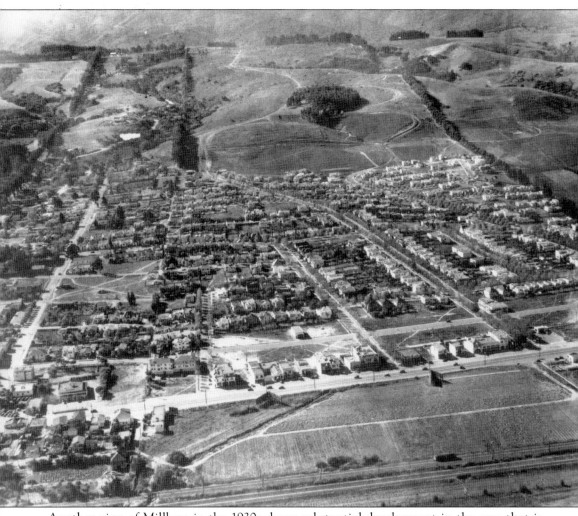

Another view of Millbrae in the 1930s shows substantial development in the area that is now El Camino Real, Broadway Avenue, and Magnolia Avenue, but not much at all in the highlands just yet.

Three

TRANSPORTATION

Today Millbrae touts its convenient mid-peninsula location as a selling point to businesses and residents, and it was the same in the early days. Situated on the rail line between San Francisco and San Mateo (and, later, the CalTrain line extending south to Gilroy), the town never wanted for train service. Mills Field, a humble airstrip out by the bay, morphed over time into San Francisco International Airport, helped along by the excavation of hills in Millbrae.

The 40 Line interurban streetcar rumbled through Millbrae as it headed between San Francisco and San Mateo. (In some cases, these streetcars carried passengers to Millbrae whose motives involved gambling, which had been made illegal in San Francisco proper around the beginning of the 20th century.) Many photographs still exist of this vanished streetcar line, which rivaled today's ultra-modern Bay Area Rapid Transit (BART) system in commute speed and convenience.

Before the streetcar era, of course, there were the larger trains, beginning in the 1860s with the completion of the Southern Pacific line south of San Francisco. Steam, and later diesel, locomotives came through Millbrae, ferrying construction supplies—such as lumber from the peninsula's southern forests—to be used in construction projects in San Francisco. Some trains unloaded their cars right in Millbrae, most notably at the Royal Container Company, a large-scale manufacturing concern. In 1890, the *Redwood City Times Gazette* noted, "The new depot which the Southern Pacific Company is building in Millbrae is one of the most commodious and architecturally pretty structures on the line."

Today many of the artifacts of the quaint rail era are gone, and the old Millbrae Depot (which was destroyed by fire in 1890 and again in 1906 and was rebuilt in 1907) has been bypassed by the new combination BART and CalTrain station near Millbrae Avenue. The old station still exists as a train museum, operated under the auspices of the Millbrae Historical Society.

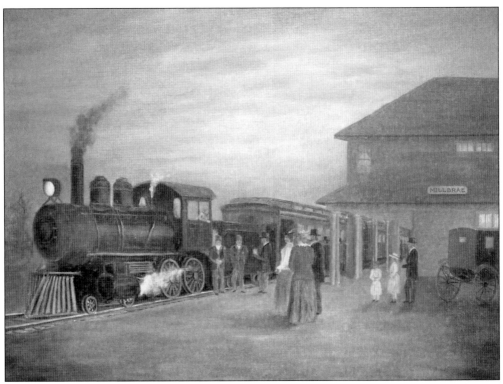

This oil panting by Joseph Hakl depicts a scene at the Millbrae depot in the early days of rail transportation.

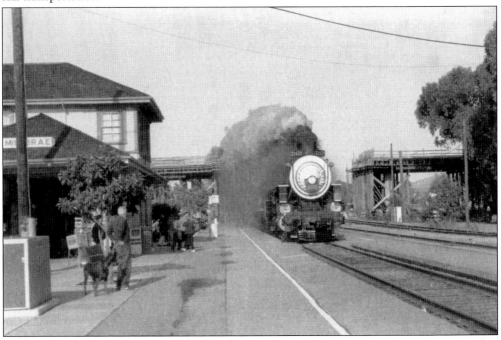

A restored, former peninsula commute locomotive pulls into the Millbrae station on December 20, 1995.

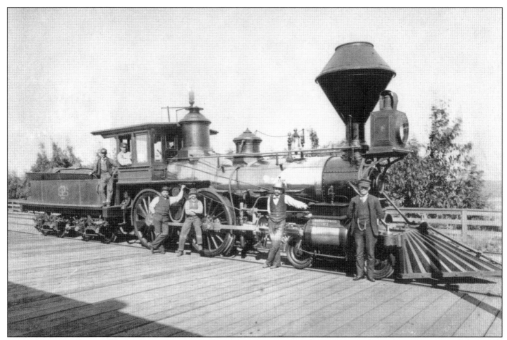

Seen here at the Millbrae station around 1920 is an 1881 Atlantic-type locomotive, complete with cowcatcher. As evidenced elsewhere in these pages, such a device was not entirely superfluous in Millbrae's early days.

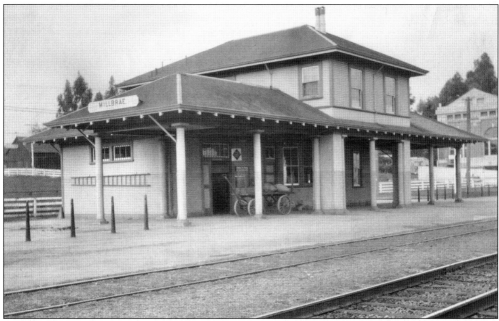

The first Millbrae train depot was built in 1863, when the railroad was constructed. The land for the depot was donated by Darius Ogden Mills. The depot was destroyed by fire in 1890 and again in 1906; it was reconstructed in 1907. The building was listed on the National Register of Historic Places on September 1, 1978. Today it serves as the train museum for the Millbrae Historical Society.

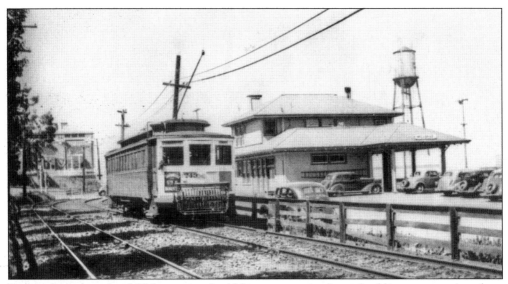

During the early and mid-20th century, the 40 Line was a major form of public transportation along the peninsula. Thousands of students rode the line on a special car for students only. Another special car was the funeral car, which carried caskets and families to the Colma cemeteries.

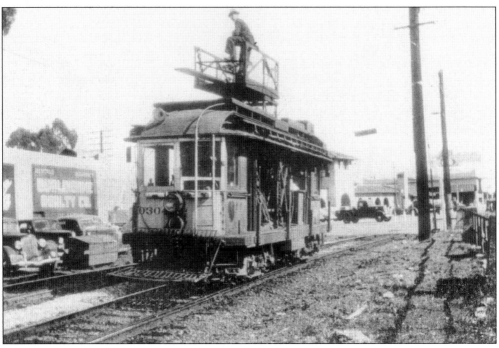

In this mid-1930s image, a maintenance car cruises along the 40 Line.

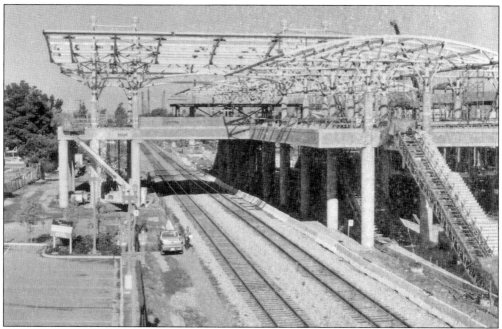

The modern train era came to Millbrae in the early part of the 21st century, when the Millbrae station was constructed as the San Mateo County terminus of the BART system. Shown here under construction in December 2000, the station opened in June 2003, providing BART service to the nearby San Francisco International Airport and to other destinations on the line.

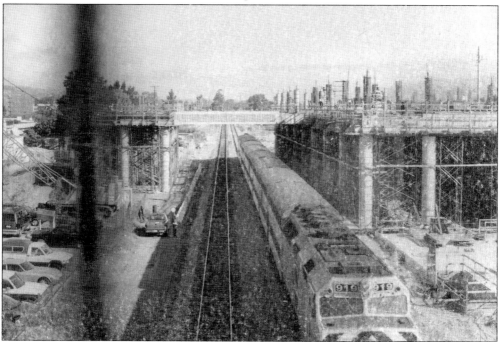

Shown here during construction on July 7, 2000, the Millbrae BART station provides a link with CalTrain, the longtime passenger train service to the peninsula and south to Gilroy. In this image, a northbound train pulls into the station.

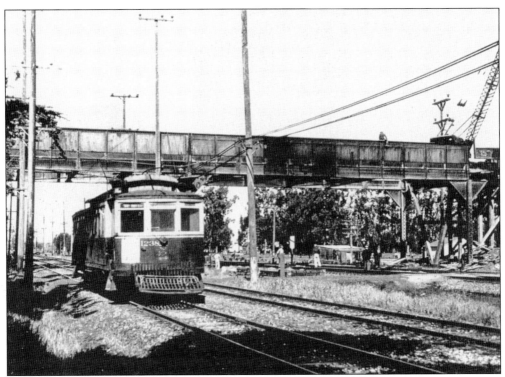

A 40 Line streetcar passes under the overpass built by the developers of Millbrae Meadows. The developers ran trucks of dirt from the Millbrae Meadows location to fill in land for the San Francisco International Airport.

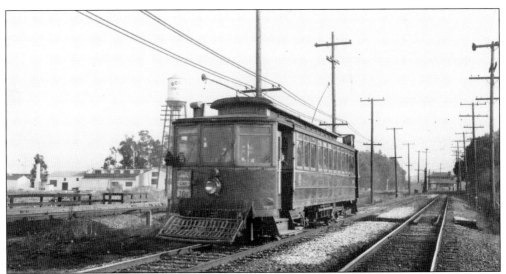

This 40 Line streetcar, on its way to San Francisco after passing the Millbrae train depot, shown in the background to the right, is passing by the Royal Container Company, formerly known as the West Coast Porcelain factory.

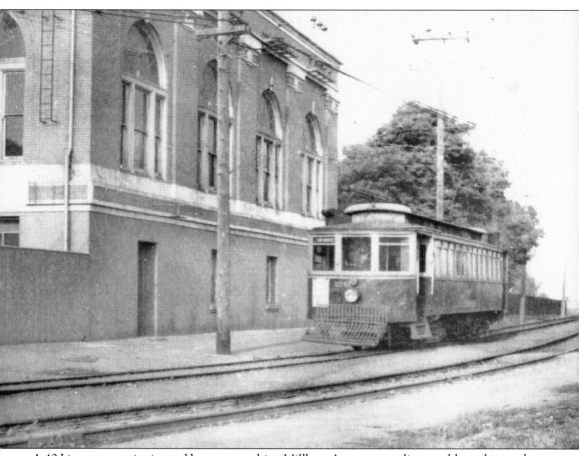

A 40 Line streetcar is pictured here approaching Millbrae Avenue, traveling southbound around 1925. The building on the left is the powerhouse that supplied electricity to the streetcars.

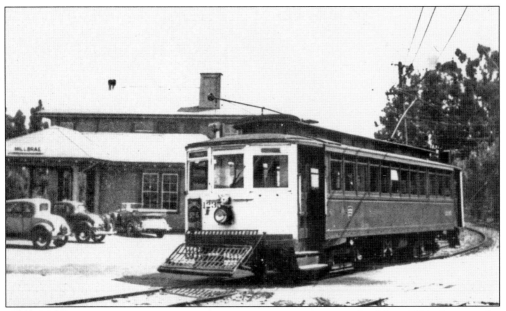

In this *c.* 1931 photograph, a 40 Line car pulls up to the Millbrae station, almost three-fourths of the way to its final destination in downtown San Mateo. Note the cowcatcher.

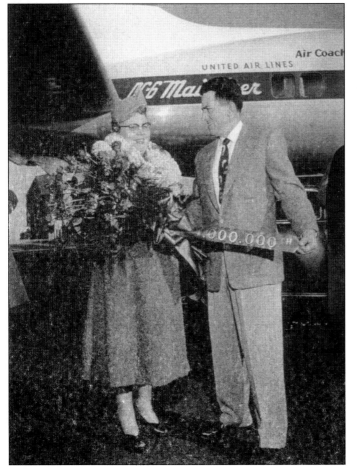

Silvio Massolo, who operated the San Francisco International Airport Florist, had the privilege of presenting the millionth passenger at San Francisco International Airport with a beautiful bouquet of flowers in the mid-1950s.

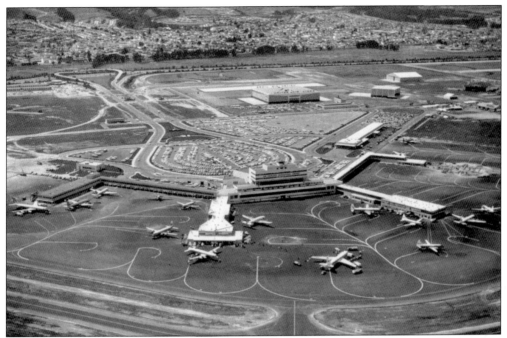

The San Francisco International Airport is adjacent to Millbrae, having sprung up from modest beginnings as a dirt landing strip called Mills Field. Opened in 1927 in the midst of swamps and cow pastures, it has gone on to become one of the world's busiest airports. A major link for business between the United States and Pacific Rim countries, the airport has undergone continuous expansion during its history. Residents of Millbrae have waged occasional battles with the airport regarding noise and construction, but the relationship has been mostly peaceful. The facility is shown here in the mid-1960s.

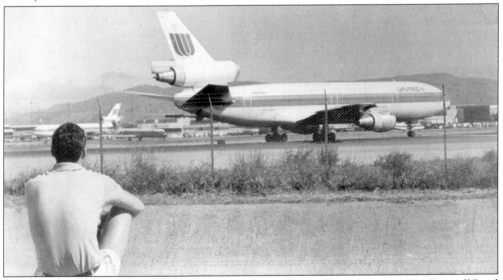

For many years, it was a popular pastime to relax at the end of Millbrae Avenue and McDonnell Road near Highway 101, watching the planes take off at the airport. As seen in this mid-1970s image, it was a casual endeavor and fun for all ages. However, the terrorist attacks of 2001 changed airport security dramatically, and this close vantage point is no longer open to the general public.

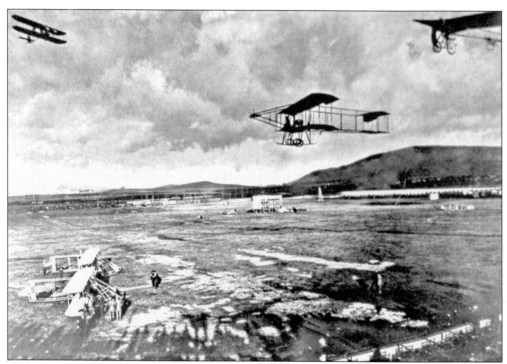

In this image of Mills Field in the early 1920s, the planes have been added in by retouching. Mills Field, located on the grounds of the current airport and stretching into some parts of Tanforan, was the predecessor of San Francisco International Airport.

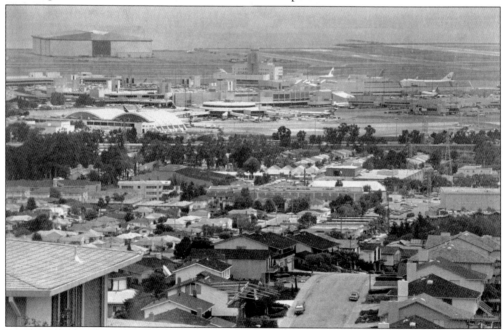

By 1990, when this photograph was taken from the Millbrae Highlands, the airport had expanded many times. The huge new international terminal had yet to be constructed; it was opened in 2000.

This 1940s aerial image of San Francisco International Airport and Millbrae shows substantial housing developments in the flatlands and hills, squeezing out much of the city's former agricultural land. Pits and quarries can be seen towards the top of the image; these supplied much of the fill for the airport's expansion out into the bay.

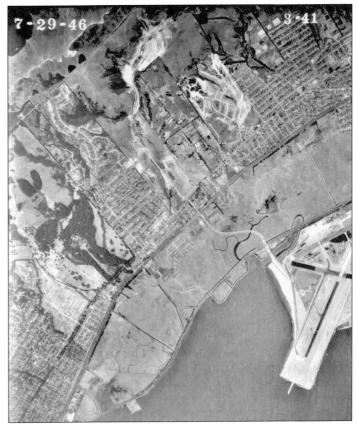

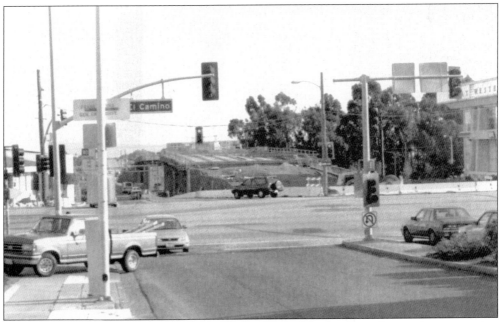

The Millbrae Avenue overpass, pictured in the center background, is shown here under construction in 1995.

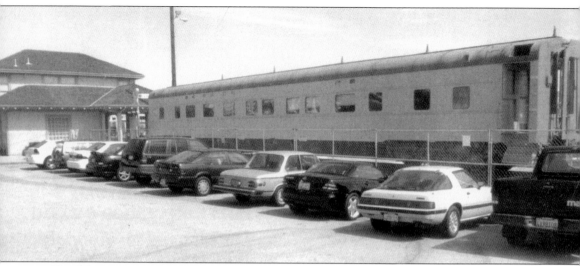

The deluxe 1941 Pullman sleeping car called the *Civic Center* was once part of the famed streamliner *City of San Francisco*. It is now part of the Millbrae Caltrain Station Museum, which can be toured on Saturdays from 10:00 a.m. to 2:00 p.m.

Four

SCHOOLS AND CHURCHES

Like any growing city, early-20th-century Millbrae found itself in need of schools for the offspring of its new settlers and places of worship to accommodate the many faiths that people brought with them as they arrived in the new world (or just a new city).

The first schoolhouse was set up in the 1890s and was a humble one-room affair. Its original complement of 19 students (including children from San Bruno, Lomita Park, and Northern Burlingame, in addition to Millbrae) seems positively quaint compared to the more than 2,000 enrolled today, but the Millbrae Elementary School District had to start somewhere. More schools cropped up over the years, including the Chadbourne School, Lomita Park Elementary, Taylor School, Green Hills Elementary, Meadows Elementary, and, later, Mills High School and Capuchino High. This last is technically in San Bruno, but it has served many Millbrae residents over the years.

Churches, meanwhile, continue to serve the faithful of Millbrae's community, from St. Dunstan's Church, dedicated in 1914, to the Community Methodist Church, to today's various places of worship. These, the schools, and the businesses all help to form the web of community that is Millbrae.

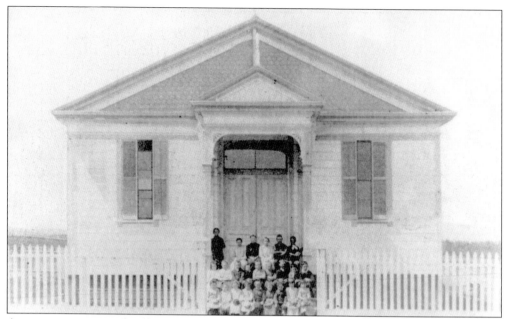

An austere one-room schoolhouse was established in Millbrae in 1893, marking a humble beginning for the Millbrae Elementary School District. It was named the Millbrae School and enrolled 19 students. Today the district has five schools and approximately 2,196 students.

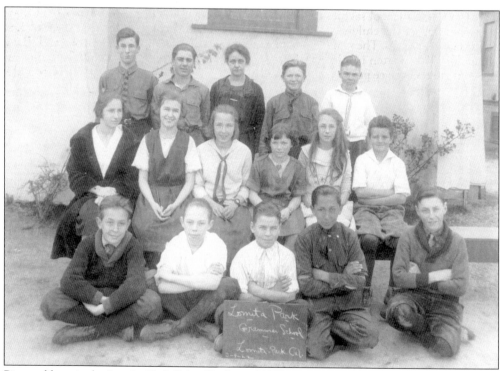

Pictured here is the Lomita Park School's class of 1922.

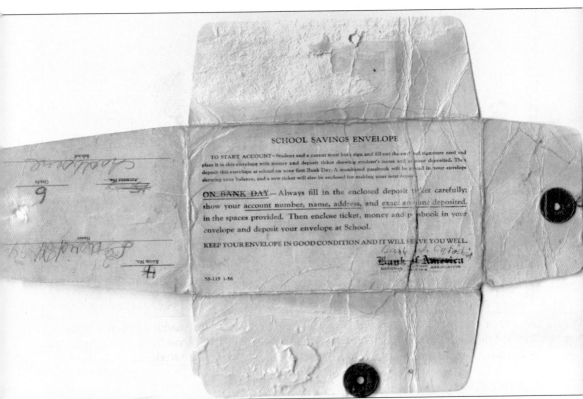

This is a c. 1930 school savings envelope from Chadbourne School. The idea behind these envelopes was for the children to start savings accounts to buy supplies and to support their schools in the process. The name "Bank of America" on the envelope is crossed out, and "Bank of California" is written in its place. Darius Ogden Mills started the Bank of California. An ominous piece of advice printed on the envelope reads "always take care of your envelope and it will serve you well."

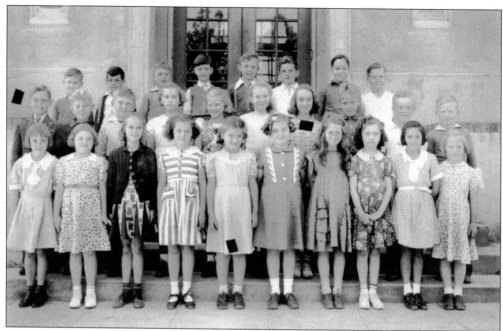

In this photograph of Millbrae Elementary School's class of 1939, Ernest W. Gee, son of early resident Alfred Gee, is the student on the left in the second row. In the first row, center, with a black square on her dress is Barbara Pallas.

The Chadbourne School staff poses for a photograph in 1940. Pictured are, from left to right, Carolyn Blair, Alice Pengelley, custodian Mac McCarthy, Florence Schroeder Kayhill, Marjorie Hill, and Olive Cereghino.

The 1946 Chadbourne School staff are, from left to right, Muriel Richards, Wilma Pengelley, Maxine Norman, Alice Pengelley, Olive Cereghino, Elana Frappiono-Cecini, Olga Owens, Ruth Rogers, and custodian Mac McCarthy.

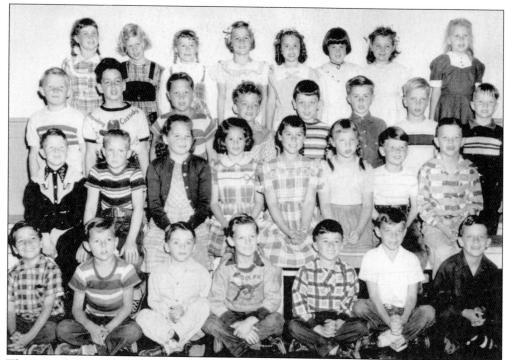

The second-grade class of Chadbourne School in 1951 included, from left to right, the following: (front row) Richard Seafire, David Finlay, Jimmy Borango, Bobby Psioda, Robert Charrot, John Akerman, and Charles Stewart; (second row) Joe Mayer, Pat McAweeney, Terry Lawton, Eileen Wexler, Lyn Laird, Francis Keeley, and Jimmy Daly; (third row) Brian Bjork, Ronnie Rossi, Jack Siddely, Michael Segal, Johnny Wemple, Dick Dennedy, Tommy Atchison, and Jack Scranton; (fourth row) Mary Ann Heagarty, Carol Ann Johnson, June Masi, Bonnie Murdock, Diane Silven, Pamela Godfrey, Carol Spears, and Marion Schneider.

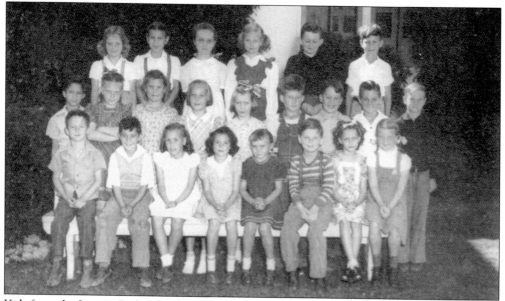

Kids from the Lomita Park School kindergarten class of 1941 strike a jaunty pose.

A few years later, in 1946, another kindergarten class stands in front of Lomita Park School's front doors.

ACTIVITIES	Quarter 1	2	3	4
Oral expression		/	S	S
Rhythm		/	/	S
Singing		S	S	S

USE OF MATERIAL	1	2	3	4
Scissors		/	S	S
Crayons		/	S	S
Paper		S	S	S
Paste		S	S	S
Clay		S	S	S
Cloth				
Paint				
Wood				
Tools				

ATTENDANCE	1	2	3	4
Times Tardy			3	1
Days Present	38	38	17	34
Days Absent	10	6	28	15

EXPLANATION
S Satisfactory U Unsatisfactory I Improving

HEALTH	1	2	3	4
Your child should have cleaner				
Uses his handkerchief				
Keeps hands and things away from face	S	S	S	S
Weight	37			
Observes rest periods	S	S	S	S

CITIZENSHIP	1	2	3	4
Consideration of others in work or play	S	S	S	S
Attention when others are talking	/	S	S	S
Shows courtesy: Remembers to say				
Please	S	S	S	S
Thank you	S	S	S	S
Excuse me	S	S	S	S
Good Morning				
Good-bye	S	S	S	S
Refrains from crying over trifles	S	S	S	S
Completes what he begins	/	/	/	S
Responds to directions quickly	/	U	/	S
Helps in keeping room clean	S	U	S	S
Keeps his hands to himself	/	/	S	S
Works, plays with others agreeably	S	S	S	S
Speaks plainly and quietly	/	S	S	S

The devil's in the details in this report card from the fourth-grade class of Lomita Park School of 1941. Aside from academic performance, children were rated on such qualities as "keeps his hands to himself," "uses his handkerchief," and the all-important "refrains from crying over trifles." This report card was for Robert English.

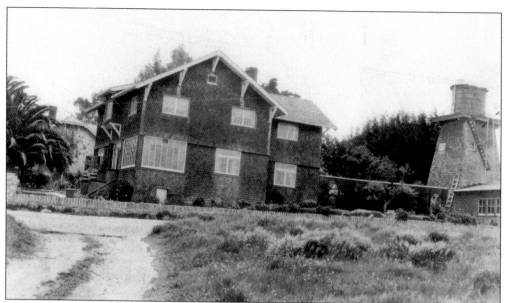

Pictured here around 1920 is the Johnson home, where catechism classes and masses were held before St. Dunstan's Church and School were built. Notice the water tank at the right of the photograph. Most homes had their own wells and windmills for their water.

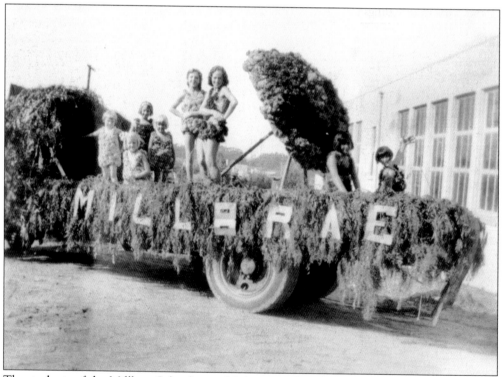

The students of the Millbrae School assembled quite a float for this *c.* 1929 parade. Reflecting the agrarian nature of Millbrae at the time, it was made of fresh greens and flowers and would not have seemed out of place at the Rose Bowl in Pasadena.

Lomita Park School

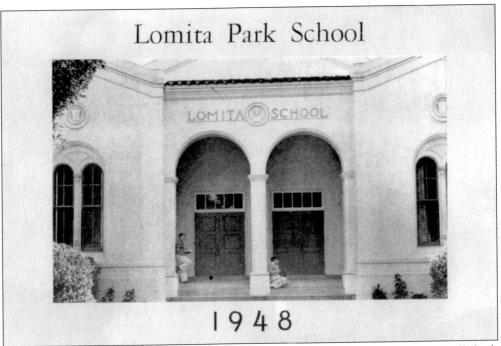

1948

This is the cover of the Lomita Park School brochure from 1948. The school was originally built in 1907, and the buildings were demolished and rebuilt in the 1970s.

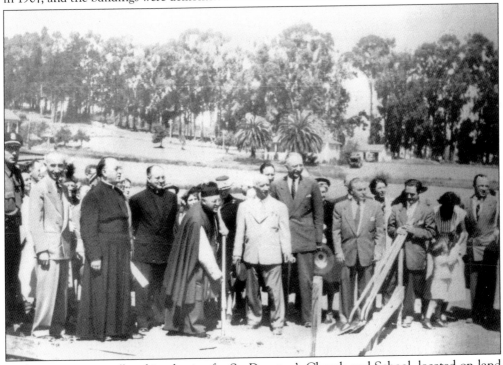

In this image, groundbreaking begins for St. Dunstan's Church and School, located on land formerly owned by the San Francisco Water Department. Construction for the current convent and school buildings began in 1950.

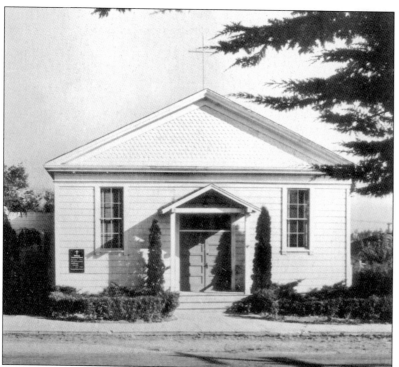

The Community
Methodist
Church was
built in 1936.
It later became
a schoolhouse.

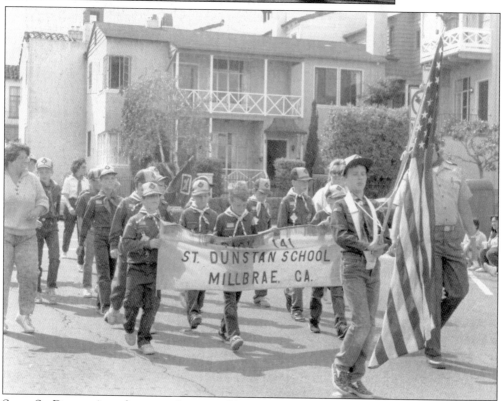

Some St. Dunstan's students march in a Millbrae parade in the 1970s.

The original St. Dunstan's Church building, designed by architect J. J. Donovan, was constructed in 1914 by builders J. J. Maloney and A. B. Cavanaugh. The church was dedicated on Sunday, May 24, 1914. J. J. Donovan donated his services for this building, which measured 22 feet by 50 feet and had 10 pews. The cost was $500 for the lot and $2,000 for the structure. In 1948, the building was widened some 12 feet without changing its appearance. The building still exists on the corner of Hermosa Avenue and El Camino Real; it is now Our Lady of Lebanon Maronite Catholic Church.

Taylor School was built in 1939 on Taylor Boulevard and almost immediately tapped into a high level of community spirit. In 1945, a total of $44,178.15 was raised by the sale of war bonds through Millbrae schools.

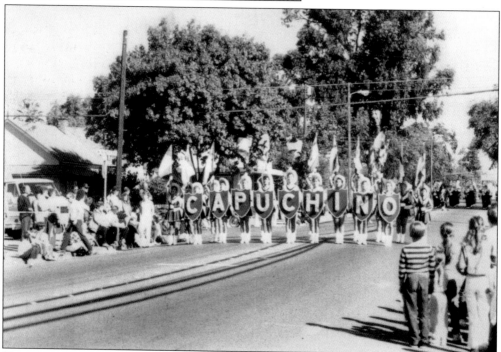

Here is a Capuchino High School parade in the 1960s. The school, one of two high schools in Millbrae (the other is Mills), was dedicated in the 1950s.

Five

A BASEBALL TOWN

Great baseball players past and present have called Millbrae home. The immortal George "High Pockets" Kelly, who played for the New York Giants and is listed in the Hall of Fame, built a home for his family high on a hill in Millbrae in the mid-1920s. Tony Lazzeri, the New York Yankees' second basemen who played with the incomparable Joe DiMaggio and was part of the Yankees' famous "Murderer's Row," also lived here. Joe DiMaggio himself was a regular visitor to Millbrae. Many of his friends migrated from San Francisco to Millbrae, giving DiMaggio the chance to reminisce with them and enjoy the food at local Italian delicatessens. Even the Lai Lai restaurant is known as a stop on the baseball circuit thanks to former Oakland A's star Reggie Jackson, who touts its cuisine.

Gus Suhr, known as the National League's "Iron Horse," was a Millbrae resident and a member of the Pittsburg Pirates. He owned and operated a liquor store here; his wife, Marion, became the first female police officer in Millbrae. Gus Suhr lived until he was almost 100 years old.

Other prominent players, such as Gregg Jeffries and Keith Hernandez, also have roots in Millbrae. In recent times, coach Tony Santora, known as "Mr. Baseball," has seen several of his former charges make their way to the major leagues.

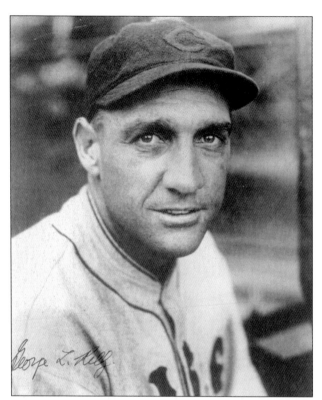

The great George Kelly (1895–1984), the first player to hit home runs in six consecutive games, is immortalized with a plaque at the flagpole in front of the Millbrae Museum.

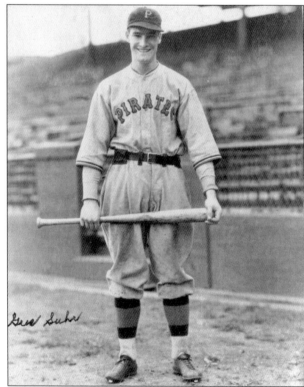

Gus Suhr (1903–2004) is pictured here during his time with the Pittsburg Pirates, with whom he played from 1930 to 1939. He also played for the Philadelphia Phillies and the San Francisco Seals.

Local resident and man-about-town Robert Gee was also a baseball enthusiast. Here he is suited up to play a local game with the San Bruno Merchants team.

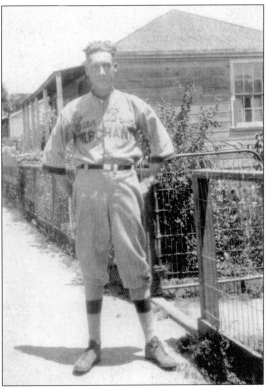

Local boy makes good! Former Millbraen Gregg Jeffries had an impressive career as an infielder in major league baseball from 1987 to 2000. He played for the New York Mets, the St. Louis Cardinals, the Philadelphia Phillies, the Kansas City Royals, the Los Angeles Angels, the Anaheim Angels, and the Detroit Tigers.

Tony Santora and his family moved to Millbrae in 1951. When he retired from a career as a lithographic press operator, he began coaching baseball leagues. He was the athletic director and baseball coach at St. Dunstan's School in Millbrae for 15 years. He later coached the Babe Ruth League in Burlingame and then the Police Athletic League of the Millbrae Police Department. He put several players from this league on the road to Major League Baseball.

Keith Hernandez, along with Gregg Jeffries, was one of Tony Santora's success stories. (Note that this photograph is inscribed "To Tony.") Hernandez played in various local leagues around Millbrae and San Bruno before moving on to the St. Louis Cardinals, the New York Mets, and the Cleveland Indians. He appeared in a *Seinfeld* episode as well, in which he both spoke and thought to himself the memorable line, "I'm Keith Hernandez."

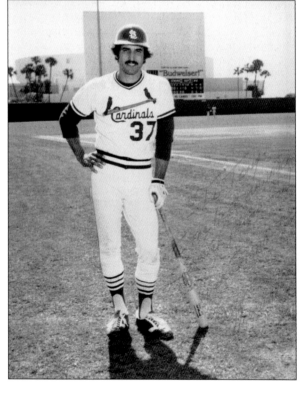

Six

MILLBRAE MEANS BUSINESS

When the first Italian immigrants came to Millbrae around 1900, they grew flowers and vegetables for the San Francisco market and for their own use. The Electric Railway Company, with service between San Francisco and San Mateo, provided for an influx of residents and workers. Among the biggest employment draws were the Millbrae Dairy and the West Coast Porcelain factory, which later became the Royal Container Company and then the Georgia-Pacific Company. The same parcel of land, located at Rollins Road and Millbrae Avenue, was later used by Cal Worthington Used Cars, then the Hertz rental car company, and finally by Bay Area Rapid Transit (BART), which built the Millbrae terminal there.

From the early 1930s into the 1950s, Millbrae's small business center was located on El Camino Real, going north from Millbrae Avenue to Meadow Glen. The exception was the 16-Mile House, which was located on Center Street and El Camino Real. Some of the better-known businesses were George's Place, established in 1938; Jensen's Creamery, established in 1937; Pair O' Jacks; Kilpatrick's Grocery Store; the Purple Cow; Kings Bowl; Martinelli's Steak House; and Millbrae Lock (formerly Millbrae TV). The West Coast Porcelain factory, located at Millbrae Avenue and El Camino Real, was established in 1919 and burned down in 1939. It was not rebuilt, and the property was sold to the Royal Container Company.

Along El Camino Real there were—and still are—a number of gas stations, many competing at all four corners of the road. The Flying "A" Association was at El Camino Real and Taylor Boulevard, while Dawdy's Shell was at El Camino Real and Hillcrest Boulevard, along with a Standard station and a Texaco station.

The business section along Broadway really came to life in the 1940s. There was a building boom between Taylor Boulevard and La Cruz Avenue. The Purity and Safeway stores were operating at this time, as well as the Five and Ten Cent Stores. The Bank of America, Suzanne's Cake Box, Millbrae Hardware Store, and Hillcrest Pharmacy were some of the new arrivals on the 300 block of Broadway, joined later by Archie's Cobbler Shop and Millbrae Jewelers. At the Brick O' Gold, a candy store, owner Howard Cobb used roller skates to travel to and from the back and around the premises. Other businesses included the stationary store and the Sun Valley Dairy, managed by Art Dikas. Later businesses like the Millbrae Florist, Belvini's Shoes, Millbrae Drug, Ray's Place, Lai Lai, and many more began serving the public of Millbrae.

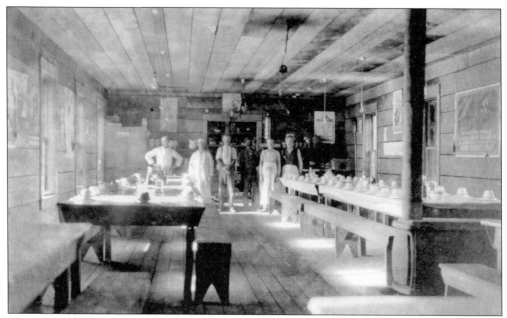

The interior of West Coast Porcelain is shown here around 1920. The workers are making sanitary equipment such as toilets and sinks. As a sideline of its main business, the company also made vases and ashtrays. (Courtesy Ernest W. Gee.)

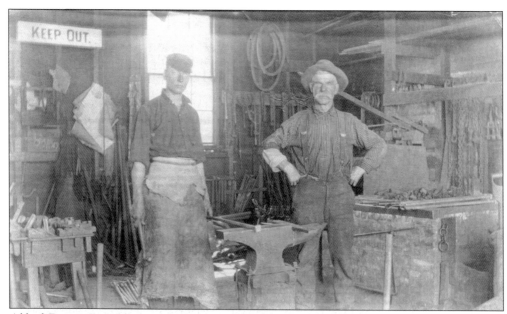

Alfred Ernest Gee's blacksmith shop operated from just after the 1906 earthquake until the 1940s. Gee, originally from England, learned to blacksmith in the U.S. Army. His was the last blacksmith shop in town. (Courtesy of Ernest W. Gee.)

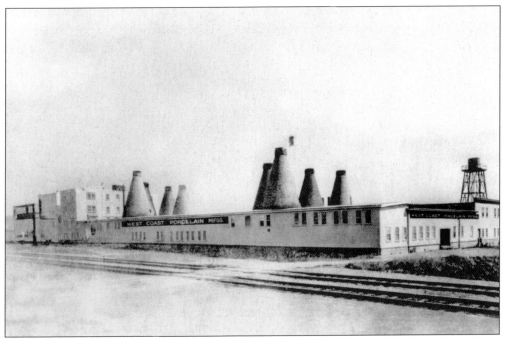

The West Coast Porcelain factory, shown here in 1919, had large smokestacks and employed several hundred workers, including Alfred L. Gee (Alfred Ernest Gee's son), who worked there as a potter.

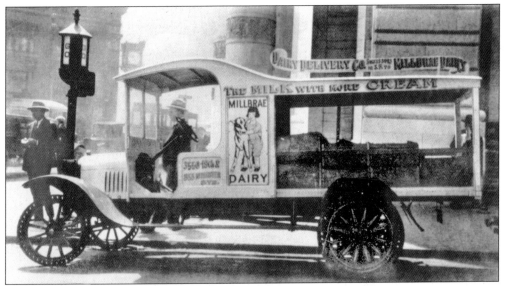

A truck from the Millbrae Dairy makes the delivery rounds in downtown San Francisco around 1925. Note the mechanical stop sign at left.

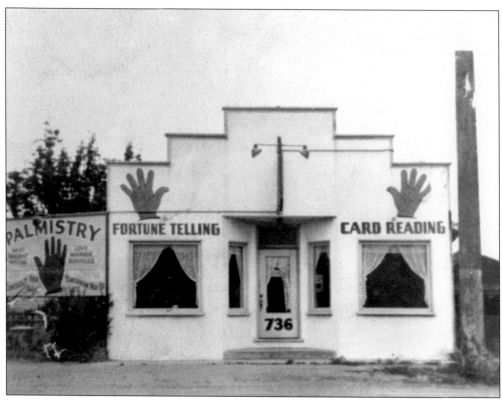

By the late 1940s, all types of businesses had come to Millbrae, including this fortune teller's studio at 736 El Camino Real.

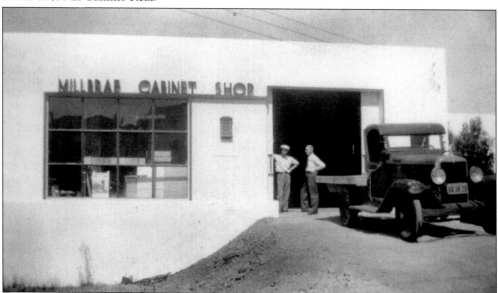

The Millbrae Cabinet Shop, seen here in 1938, has been handed down from one generation to the next. Emil Helmig started it in 1936 and handed it to son Robert, who in turn handed it to son Kevin. The only business in Millbrae to span three generations, it was given a community preservation award by the city in 2004.

The Royal Container Company produced corrugated boxes of all shapes and sizes for a varied clientele, including members of the wine industry. It was incorporated in 1933 in San Francisco and moved to Millbrae in 1941. Here a starch master known as "Limey" checks a batch of starch for an upcoming box run.

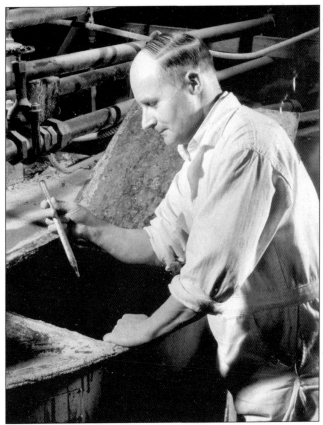

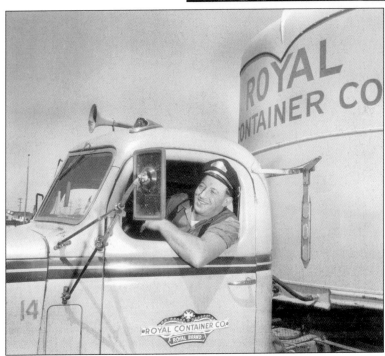

Louie Wilson of Royal Container, whose idea it was to move the firm from San Francisco to Millbrae, poses in a company truck around 1949.

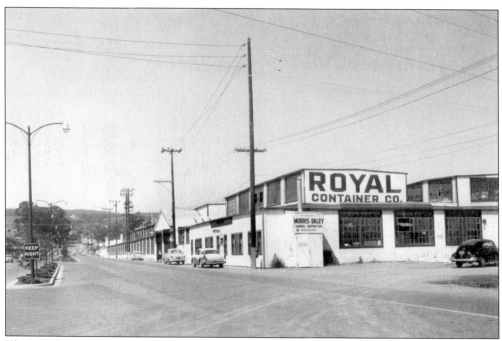

The Royal Container plant, located at the site of the present-day BART station, covered more than 10 acres. Here it is as it appeared just after opening in 1941.

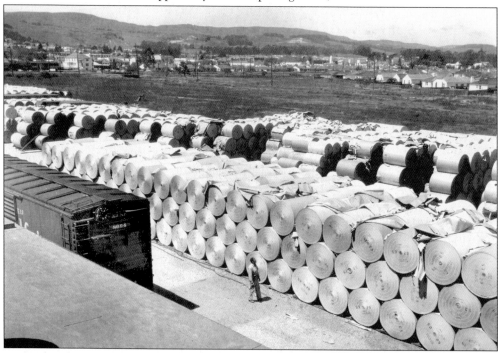

Raw materials await processing in this 1960 image of Royal Container's back lot. The huge rolls are pulp board, each weighing from 2,000 to 5,500 pounds, which were shipped to the company for use as the facing of the corrugated boxes that it produced. Note the boxcar at the left of the photograph; Royal was an industrial-strength operation.

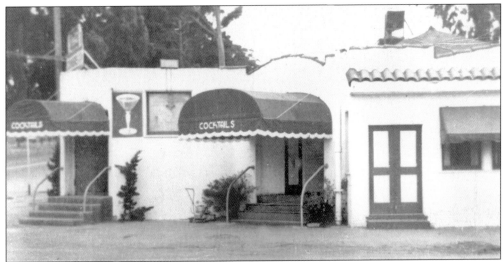

The Crossroads was a popular cocktail restaurant at El Camino Real and Millbrae Avenue; today a gas station is in its place. This lounge was among many in the city that flourished from the 1930s to the late 1940s. The town was an "open city," featuring many nightclubs and an eager clientele that would ride the 40 Line down from San Francisco, especially on Saturday nights.

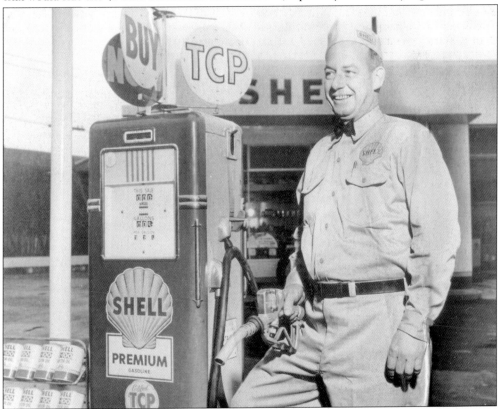

Glen Dawdy opened his first Shell station on the northeast corner of Millbrae Avenue and El Camino Real in early 1946. In 1953, he moved the station to Broadway Avenue. He passed away in 1973, and the station remained open until 1978.

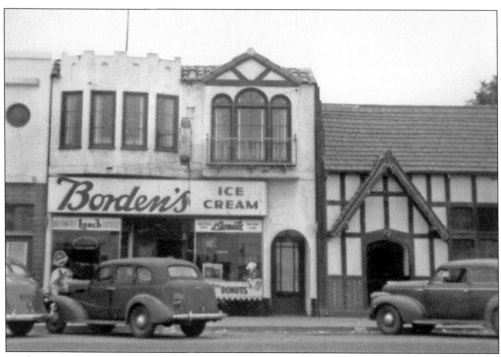

Borden's Ice Cream occupied a popular spot on El Camino Real for many years. Here it is pictured in the mid-1940s next to George's Place.

Millbrae's stretch of El Camino Real could be considered a miracle mile of sorts; dozens of businesses line either side of this state highway. This is a view near Hillcrest Boulevard in 1946.

George's Place, seen here in 1984, served for many years as an unofficial city hall: various deals were made here away from the glare of office lights. Today the building houses an Irish bar called Finn McCool's.

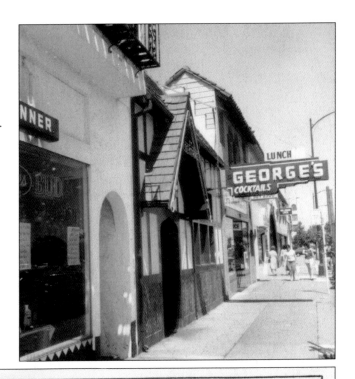

JUST ARRIVED!

New 1946 Phonographs

NOW ON SALE — COME EARLY

**RADIOS — REFRIGERATORS
WASHERS — IRONERS — VACUUM CLEANERS
AND GENEAL HOUSEHOLD APPLIANCES**

SOLD and REPAIRED

FOR PICK-UP and DELIVERY SERVICE
Call MIllbrae 2632
Martin Sweeney's

MILLBRAE RADIO and APPLIANCE

10 HILLCREST BLVD. MILLBRAE

Millbrae Radio and Appliance urged caution in this 1946 advertisement, requesting that customers "come early" to get their new phonographs. Those that did not heed this advice risked disappointment or worse.

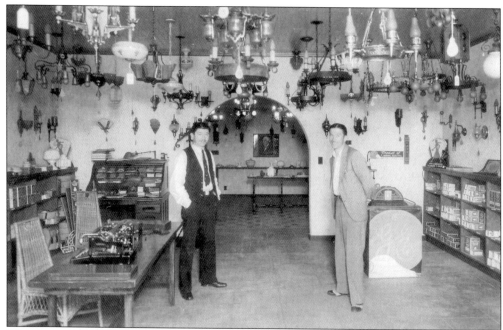

The Burlingame Electric Company, despite its name, was actually located in Millbrae on El Camino Real. This is the shop's interior around 1944.

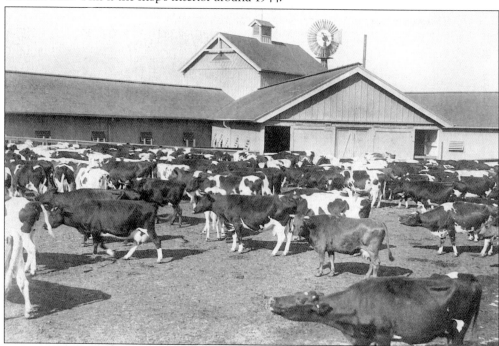

Darius Ogden Mills and A. F. Green entered into a partnership for the sale of milk in 1860; this lasted until 1866. After the dissolution, Mills took the cattle and dairy implements, while Green took over the local delivery route. Mills supplied Green with milk until 1890, when Green switched to a Marin County supplier. Mills later established the Millbrae Dairy Company. Seen here in the 1940s are some of the cows at the Millbrae Dairy, operated at the site of the Mills Mansion.

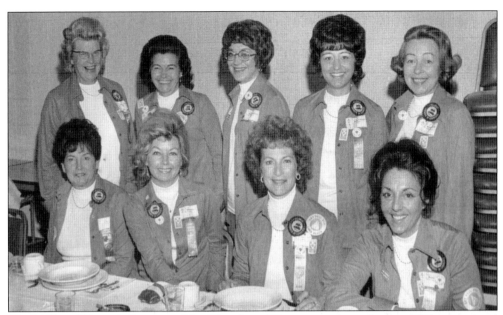

The Millbrae Women's Division of the Chamber of Commerce, shown here in 1976, was created to honor the achievements of women in the city's business community. Pictured are, from left to right, the following: (seated) Lee Lane, Felicia Bitter, Marjorie Wilson, and Helen Asimos; (standing) Valli Slate, Jean Erickson, Margie Erickson, Juanita Schmidt, and Virginia Mason. Marjorie Wilson was named businesswoman of the year in 1976.

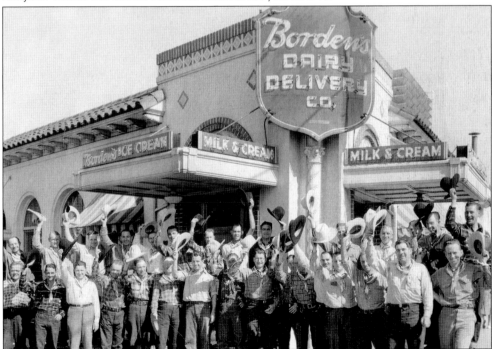

The employees of Borden's Dairy Delivery Company pose for a photograph in the early 1930s. In the early 1920s, John Daly, Richard Sneath, and relatives of Darius Ogden Mills got together to create Daily Delivery Service (DDS), which became Borden's in 1929.

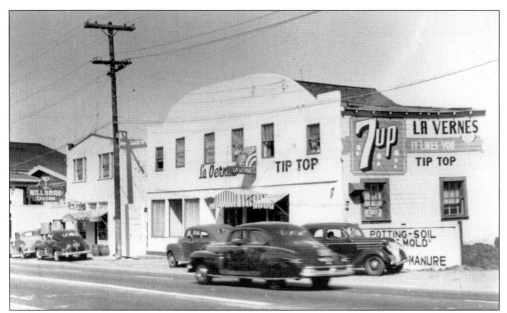

The Tip Top Inn, pictured here in 1946, was also known as La Verne's. It was one of Millbrae's early nightclubs, along with the Bit of Rhythm, the Cottage Inn, the Bungalow, Alice's Inn, and the Coral Reef.

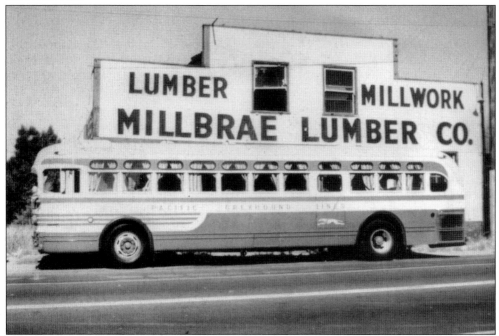

The Millbrae Lumber Company was started by Neils Schultz in the mid-1920s to provide supplies for construction in the Millbrae Highlands development, of which he was the primary developer. Schultz sold the business to Joe Hammond after the Highlands was completed, and Hammond sold to Al Guspari and Jack Jones. In turn, they sold interests to Al Guspari Jr. and Silvio Massolo. Massolo's family operated the business along with partner Dan Thurston, and it continues today as Massolo and Thurston. Pictured here is the business in the 1930s.

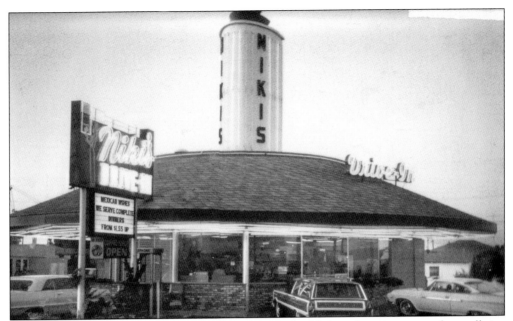

At one time, Millbrae had two drive-in restaurants, which added much excitement to the small city. Elmer C. Smith was the first owner of Smith's Drive-In. In 1956, it was sold to W. H. Schoenhals of San Francisco, who still operated it under the Smith name. The business quickly failed, and the building was boarded up. It reopened in 1958 as Niki's, named for owner Niki Cruz, and operated until 1972. Here is Niki's in the late 1950s.

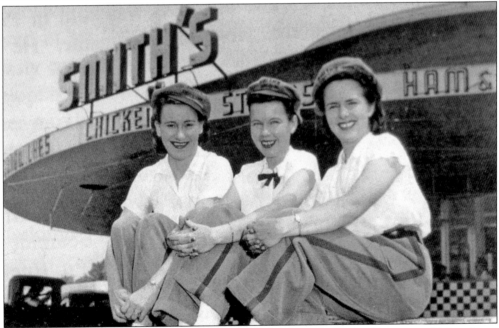

Pictured here from left to right are carhop waitresses Peggy ?, Shirley Donati, and Mary Lou ? at Smith's Drive-In in the early 1950s, before the restaurant became Niki's. Despite the familiar conical shape, this building is not the same one as the present-day Peter's restaurant located at the corner of Millbrae Avenue and El Camino Real.

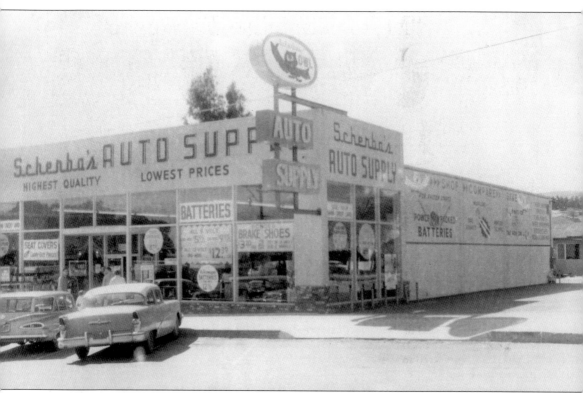

In 1946, Ted, Don, and Vern Scherba established Scherba's Auto Supply store at 316 El Camino Real in a small storefront. Successful Millbrae businessmen, the Scherbas opened stores up and down the peninsula as well as in San Francisco.

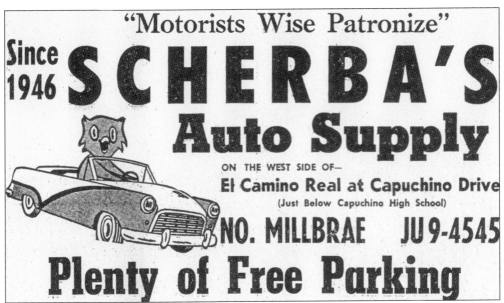

"Motorists Wise Patronize" Scherba's, as evidenced by this whimsical early 1950s newspaper advertisement of an owl driving a car. Despite the bird's lack of opposable thumbs, which would render it incapable of operating a motor vehicle, it was featured in most of Scherba's advertising. The business lasted well into the 1990s.

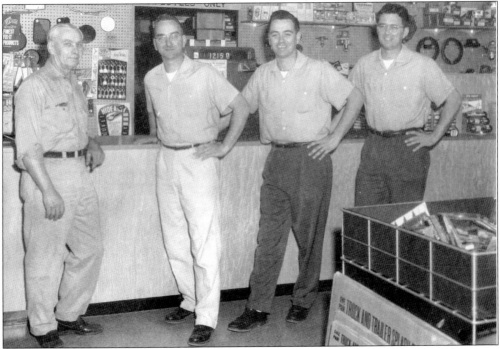

The Scherba brothers take a break at the counter of their first automobile parts store on El Camino Real around 1961. The business eventually expanded to include several stores in San Mateo and San Francisco Counties. Pictured from left to right are Isadore and sons Ted, Vern, and Don.

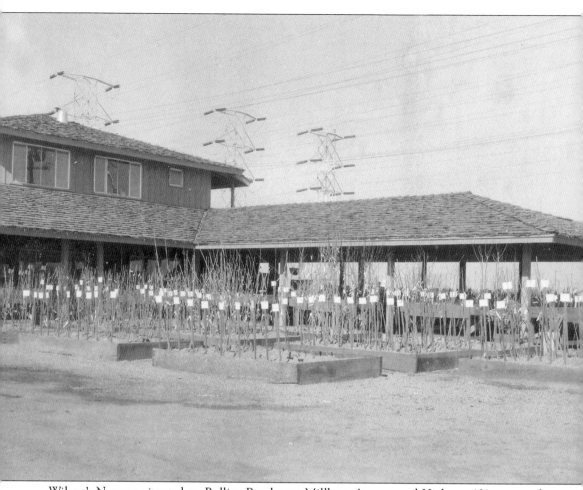

Wilson's Nursery, situated on Rollins Road near Millbrae Avenue and Highway 101, operated from the 1930s to the 1990s. It covered a large parcel of land that has now been redeveloped as a cluster of businesses, including an In-N-Out Burger and a combination gas station and mini-mart. Wilson's Nursery started on El Camino and later moved to Rollins Road.

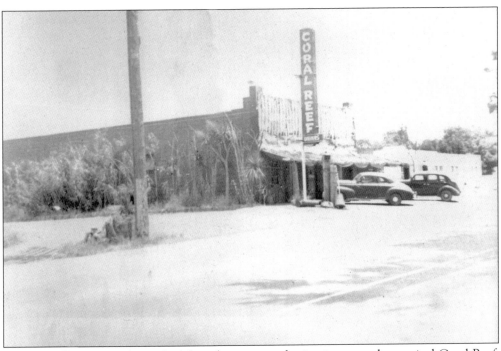

One of Millbrae's exciting nightclub and restaurant destinations was the tropical Coral Reef, seen here in 1946. Bob Hope visited Buddy and Roberta Maleville of Alta Loma Drive and was their guest at the Coral Reef restaurant in the evening. At that time, Hope was recognized as a promising young radio entertainer. He had appeared with comedian Bing Crosby, who was also a visitor to the Coral Reef in the 1940s.

The Coral Reef was one of many Bay Area restaurants that catered to the mid-century fascination with tropical and tiki themes.

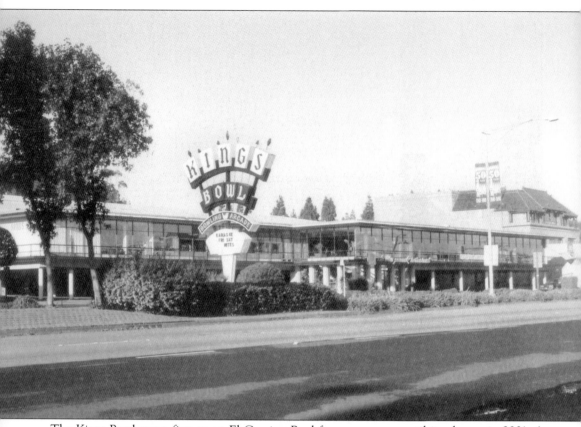

The Kings Bowl was a fixture on El Camino Real for many years until its closure in 2001. A condominium and retail complex is now located at the site.

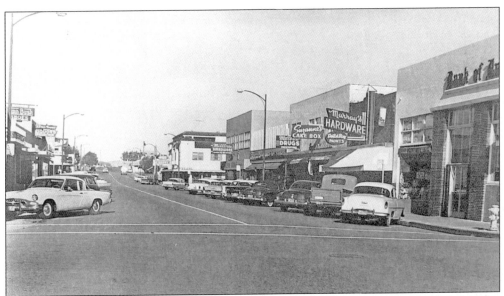

Downtown Millbrae, pictured here along Broadway in 1953, was and still is the main hub of the city's business district. In this image, the lack of foliage is apparent; later city administrations planted copious greenery along the strip for a sylvan shopping experience.

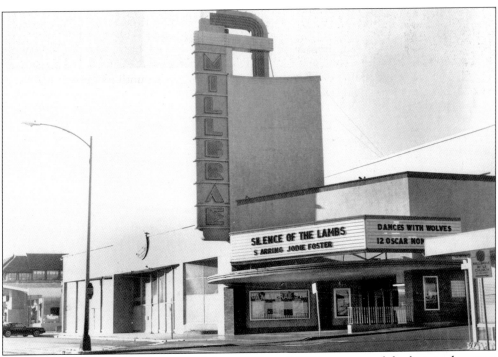

The Millbrae Cinema, which operated from 1949 until 1991, was one of the last single-screen theatres to survive on the peninsula. Seen here in its final year, it was closed to make way for residential and commercial development. As of this writing, the Millbrae sign still exists on the new building, the only clue that a cinema once occupied the site. The city stipulated that the sign be saved and displayed.

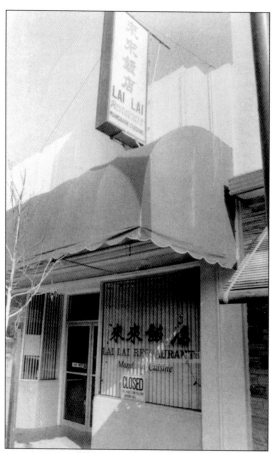

The Lai Lai (owned by Jimmie Tzeng) is a fine Chinese restaurant that has become a tourist stop because former Oakland A's superstar Reggie Jackson touted its culinary delights. Tzeng left his native Taiwan in 1968 to continue his studies in the United States. He worked at Westlake Joe's in Daly City for a time before opening Lai Lai in 1983. Rumor has it that "special" (risqué) fortune cookies are available at Lai Lai, if one knows to ask for them. Another popular nearby restaurant is the Mandarin, a family-operated business that has been around for more than 20 years.

The Noble Frankfurter, located in the Massolo Building on El Camino Real, has been operated by owners Ting-Jen "Bob" Chu and wife Junner-Shing "Jennie" Chu since 1971. Bob was born in China and was educated as an electrical engineer in Taiwan. The Chus have raised three children in Millbrae and have three grandchildren.

Seven

LIFE IN MILLBRAE

Millbrae has long traded on its slogan, "A Place in the Sun," and why not? Typically, the fog that often enshrouds San Francisco breaks just north of here, providing an oasis of sunlight that is a welcoming sight to many San Francisco commuters.

Throughout the years, Millbraens have found ways to celebrate life here. Elegant country-club golfing and dining in the hills above town, the all-inclusive Art and Wine Festival, civic events like the Miss Millbrae Pageant, yearly awards to a man and woman of the year, the thespian stylings of the Millbrae Players, the camaraderie and community spirit of the Millbrae Lion's Club, and the general healthy spirit of the populace all keep Millbrae a real city, not just a bedroom community.

The photographs in this concluding chapter are meant to show various aspects of life in Millbrae: work, play, and study. Some of the people pictured are regular citizens going about their daily lives in town or nearby, while others represent some of the city's prominent, long-term families. The common thread: they are Millbraens all.

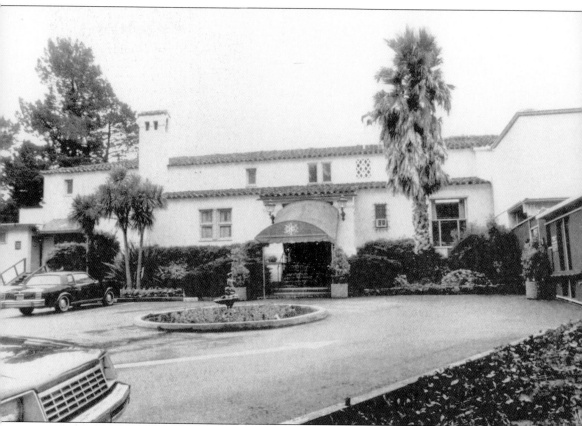

Seen here is the Green Hills Country Club. It was built by members of the Union League Club, which was composed of influential businessmen and physicians. After the 1906 earthquake, the club sought out a new location to rebuild the facility, finally deciding on the 143-acre parcel at the end of Ludeman Lane for the construction of a clubhouse and a golf course. The purchase price for the land was a mere $250,000.

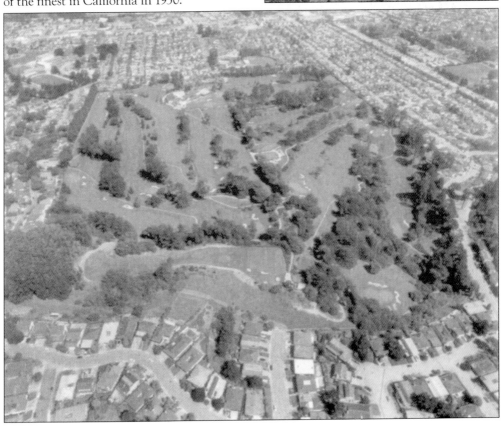

The Green Hills Country Club is a private club built on land that was originally part of Jose Antonio Sanchez's Rancho Buri Buri land grant. Dr. Alistair MacKenzie, a golf course designer, was hired to develop the property into an 18-hole golf course. When it was completed, it drew rave reviews and was considered one of the finest in California in 1930.

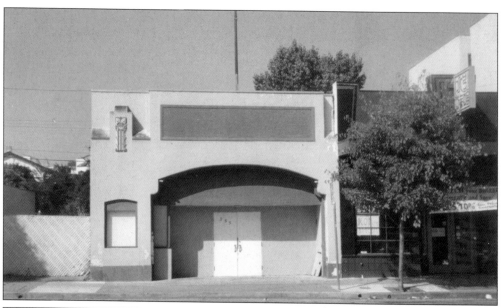

MILLBRAE COMMUNITY
PLAYERS
Affiliated With The
SAN MATEO JUNIOR COLLEGE ADULT CENTER

Presents

"ARSENIC AND OLD LACE"
by
JOSEPH KESSELRING

Directed by
RALPH SCHRAM

Friday and Saturday Nights
June 2nd, 3rd and 9th, 10th

8:15 P. M.

CHADBOURNE AVENUE SCHOOL AUDITORIUM
MILLBRAE, CALIFORNIA

The Millbrae Players, a nonprofit community organization, was open to anyone interested in any phase of play production. The group was affiliated with the San Mateo Junior College Adult Center, and the plays were supervised by experienced director Ralph Schron. The Millbrae Players first performed in the Chadbourne School auditorium, but they later had their own facility, a firehouse on Broadway that had been converted into a theater. The building is seen here in modern times.

This is an early program of the Millbrae Players when the group was still performing at the Chadbourne School auditorium. The first production, *Here Comes Mr. Jordan*, was performed in February 1944. Other productions included *Oh Wilderness, Suds in Your Eye, Male Animal, Outward Bound, The Amazing Dr. Clitterhouse, Rebecca, Two Blind Mice, The Barrettes of Wimple Street, Remember Mama, Pygmalion, The Petrified Forest*, and several other smaller productions.

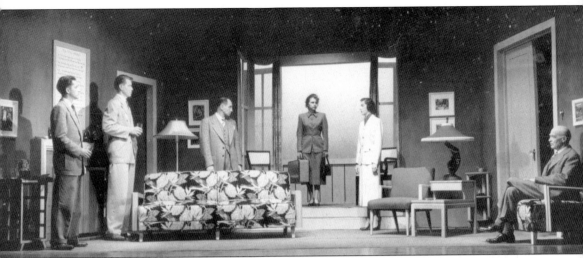

The Millbrae Players act out a scene from *Ten Little Indians*, an adaptation of Agatha Christie's 1939 novel. The group's last production was in 1954.

The Millbrae Lions Club was chartered on February 18, 1938, at the Green Hills Country Club. Ever since, the group has worked with the youth of Millbrae and supported the community. Among the club's activities are the Millbrae Lions Youth Baseball League, blood drives, pancake breakfasts, Christmas tree sales, fingerprint programs, canine companions for independence, and a youth essay contest. A notable contribution was the construction and maintenance of the Boy Scout House next to Taylor Middle School, seen here in the early 1950s.

Early Millbraens Frank and Richard English prepare for a Sunday drive in 1940. Richard was known for a time as the "bad boy" of Millbrae, but details are sketchy as to the origin of this moniker. (Courtesy of Richard English.)

In the early days, duck hunting at the bay shoreline was a very popular sport throughout the peninsula. Pictured here in the early 1960s near the San Francisco International Airport are, from left to right, Kenny Pachaeo, Frank English, and Manuel Pachaeo. (Courtesy of Richard English.)

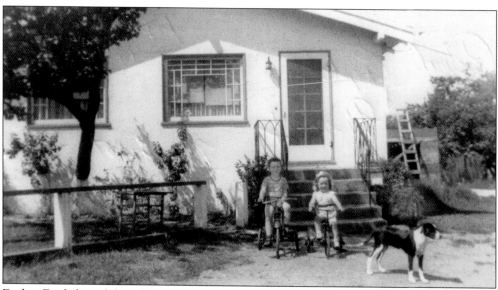

Dickie English and friend Norma Huskie ride bikes in front of the English family abode in 1942. (Courtesy of Richard English.)

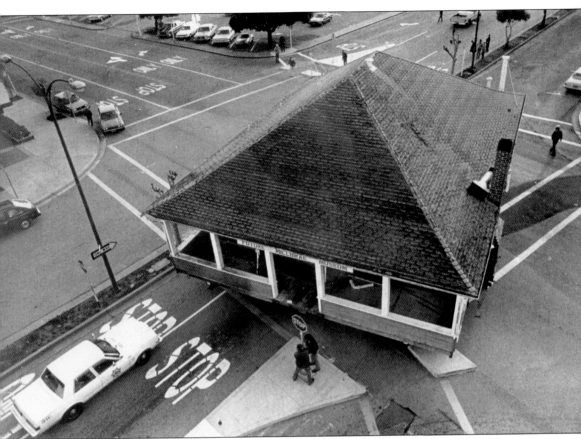

The San Francisco Water Company house, built in 1898 by the Spring Valley Water Company and later abandoned, was given to the city of Millbrae to become the Millbrae Museum. It was moved to the present location in 1985. The building is shown here at the intersection of Broadway Avenue and Taylor Boulevard as workers prepare to remove an impeding stop sign. After two years of refurbishing, the building was dedicated on April 4, 1987.

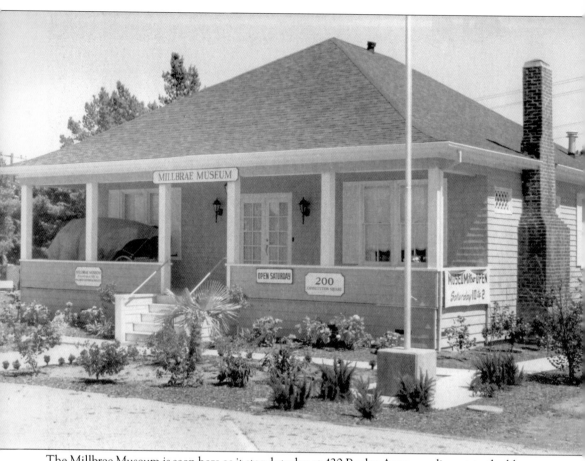

The Millbrae Museum is seen here as it stands today at 420 Poplar Avenue, adjacent to the library and police station. The 200 Constitution address is from the building's previous location.

Sophie L. Miller Gee and Alfred E. Gee pose with their three-year-old son Alfred L. Gee in 1903.

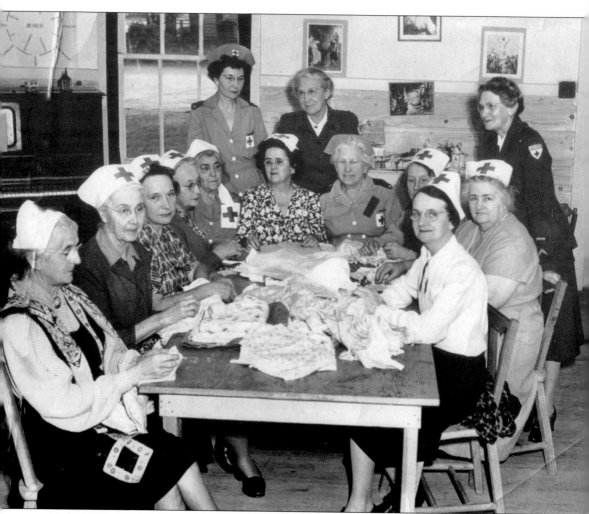

In the 1940s, Sophie Gee and friends gathered together each week at different homes in Millbrae to make bandages and other supplies for the Red Cross. After lunch, they put their work away and spent the remainder of the day in rowdy card games. (Courtesy of Ernest W. Gee.)

Alfred L. Gee, a potter by trade, worked in the West Coast Porcelain factory in Millbrae until the mid-1930s, when the plant was shut down. Also a racing enthusiast, Gee is shown here with a roadster in the highlands in the late 1920s. (Courtesy of Ernest W. Gee.)

Millbrae's annual Art and Wine Festival attracts hundreds of thousands of people to Broadway Avenue. Here is the crowd in 1971. The festival has grown substantially since then and is a major event each Labor Day weekend. In recent years, the event has featured the musical stylings of Pablo Cruise, whose 1977 hit, "A Place in the Sun," seems almost eerily suited to Millbrae.

During the 1996 construction of the Millbrae Avenue overpass, longtime Millbraen Stewart Ruggles presented the idea of placing time capsules within the structure. His idea was unanimously approved, and he set about gathering documents, articles, and objects to document Millbrae life in 1996. The objects were placed in 10 PVC capsules and pressurized to 29 psi (pounds per square inch) with argon gas. Interred into the overpass on August 3, 1996, they are expected to last hundreds of years. Here a worker indicates the location of the artifacts.

Most every Italian family in Millbrae had at least one accordionist, and sometimes two, as seen in this 1920s image.

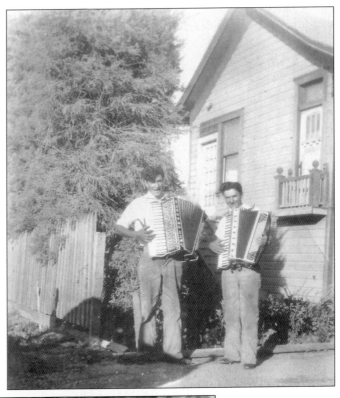

Halloween was always a fun time in Millbrae neighborhoods. Here the Mines kids, Barbara (dressed as a hobo) and Paul (dressed as a headless monster), pose with Bill Rhodes (in the monster mask) in the late 1950s. (Courtesy of Barbara Parker.)

Millbrae is not known as a filming destination, but some such work has happened here. In this image, the crew for the John Wayne film *High and Mighty* is hard at work at the San Francisco International Airport in the late 1950s.

Millbrae children enjoyed the great treat of playing in the snow when the city was surprised by a rare snowstorm. Here Barbara and Paul Mines pose with a snowman in front of their house on 32 Robert Place in the late 1950s. (Courtesy of Barbara Parker.)

The program for the 1972 Miss Millbrae Pageant has those familiar Millbrae icons of sunshine and airplanes. One never knows what can happen at these events; here, Miss Millbrae 1971, Linda Larson, looks like she is about to be narrowly missed by a miniature 747.

THE

Millbrae
CHAMBER OF COMMERCE

Linda Larson, Miss Millbrae 1971

MISS MILLBRAE 1972
BEAUTY PAGEANT

The Miss Millbrae Pageant, held from 1954 through 1990, was always a popular event. Here are some of the contestants in 1960.

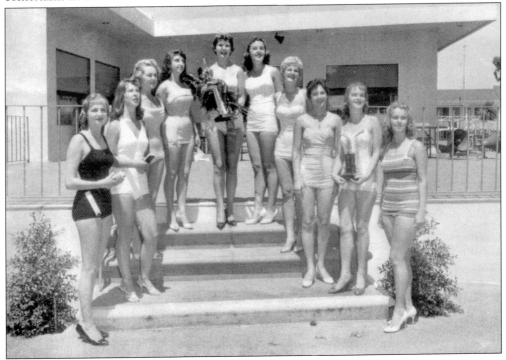

Pictured here are, from left to right, Gina Solari, Suzanne Walker, and Kimberly Geary, who were crowned Miss Millbrae in 1985, 1986, and 1984, respectively. Suzanne Walker, who now lives in the Midwest, reports of her reign some 20 years later: "It was great fun, and I got to open quite a few shops, but tragically, when a trip to Europe presented itself, I was unable to fulfill the remainder of my duties, and had to relinquish my crown."

Here is the full complement of contestants in the 1986 Miss Millbrae Pageant. Pictured are, from left to right, the following: (front row) first runner-up Georgia Pappas, second runner-up Mindy Miller, Melody Neal, and Miss Millbrae 1986 Suzanne Walker; (second row) Veronica Midgett and Celia Brush; (third row) Jackie Hart and Cynthia Patrick.

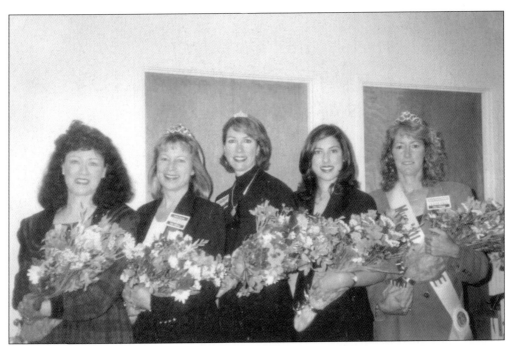

These former Miss Millbraes are, from left to right, Debbie Wright (1970), Linda Larsen (1971), Sandra Wilson (1972), Ahtossa Piroozfar (1990), and Linda Rainey (1973).

Two of the earliest Millbrae residents, Alfred "Bert" Larson (1891–1944) of San Francisco and his wife, Ethel Allen Larson (1884–1942), enjoy the World's Fair on Treasure Island in San Francisco in 1939. They are the parents of Anselma June Lyerlo.

The Larson and Lyerla families have lived in Millbrae for 86 years. Alfred "Bert" Larson purchased one of the first residential lots available and worked for the Millbrae Dairy's home delivery, first with a horse and buggy and later with motorized vehicles. Bert and his wife, Ethel, had five children: Allenbert (1919–1991), Lagyd (born in 1922), Romera (1924–1929), Anselma June Lyerla (born in 1927), and Lillian Sunderlin (1929–1963). Anselma June married Jerry Lyerla, and they raised their family in Millbrae. Their children are Sandra (born in 1946), Jerrillyn (born in 1947), Toni (born in 1949), Michael (born in 1954), Deborah (born in 1955), Gary (born in 1958), and Leslie (born in 1959). Here June and Jerry Lyerla renew their vows on their 50th wedding anniversary on July 13, 1995, at the Millbrae Methodist Church. Pictured are, from left to right, Sandra, Jerrillyn, Toni, June, Jerry, Michael, Deborah, Gary, and Leslie.

The Sister Cities program, started by Dwight Eisenhower in 1956, is alive and well in Millbrae, which has a sister city in La Serena, Chile, and another in Mosta, Malta. Seen here is the September 11, 2002, dedication by former Millbrae mayor Doris Morse of a peace pole at the Josephine Waugh Soroptimist park on Chadbourne Avenue. The event celebrated Millbrae's participation in the Sister Cities program.

Millbrae's 50-year anniversary in January 1998 was celebrated with a cake cut by Millbrae mayor Mark Church (left) and Nazzareno Vassallo, mayor of Millbrae's sister city of Mosta, Malta, who traveled to the United States for the event. The celebration, held at the recreation center, attracted nearly 600 people.

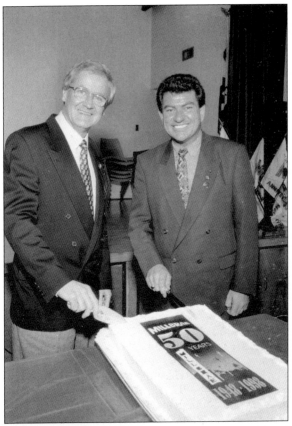

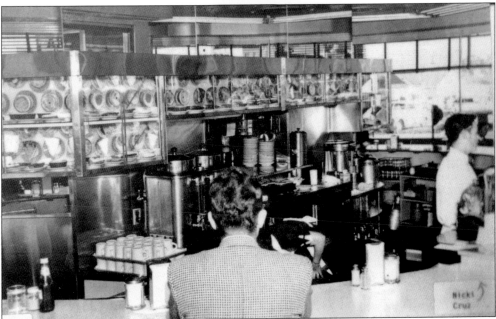

In this c. 1951 image, patrons at Smith's Drive-In restaurant enjoy the bustling surroundings, proving that one did not have to drive in to enjoy the food. (See page 97 for an exterior view.)

Tom and Faye Dawdy of Dawdy's Photography are two of Millbrae's longtime residents and businesspeople.

The Massolo family, pictured here in the 1930s, was instrumental in the early development of Millbrae's business community.

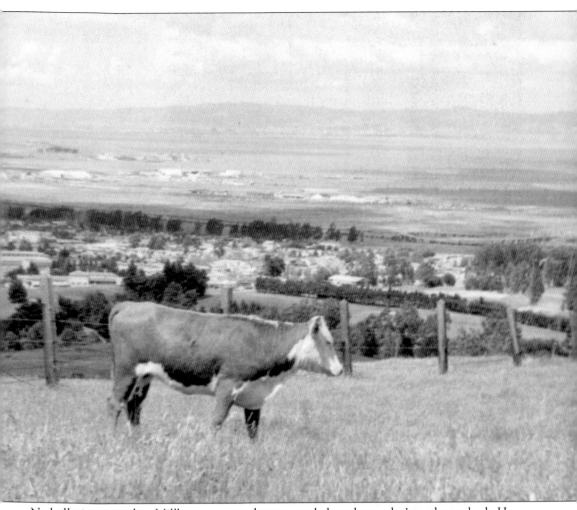

No bull: time was when Millbrae was a much more rural place than today's modern suburb. Here a bovine resident peruses the grasslands of Millbrae Highlands in 1953.

Across America, People are Discovering Something Wonderful. Their Heritage.

Arcadia Publishing is the leading local history publisher in the United States. With more than 4,000 titles in print and hundreds of new titles released every year, Arcadia has extensive specialized experience chronicling the history of communities and celebrating America's hidden stories, bringing to life the people, places, and events from the past. To discover the history of other communities across the nation, please visit:

www.arcadiapublishing.com

Customized search tools allow you to find regional history books about the town where you grew up, the cities where your friends and family live, the town where your parents met, or even that retirement spot you've been dreaming about.